ART

MONET'S WATER LILIES

'It took me a long time to understand my water lilies,' Monet wrote of his pond at Giverny. 'I had planted them for the pure pleasure of it, and I grew them without thinking of painting them. . . . And then, all of a sudden, I had the revelation of the enchantment of my pond. I took up my palette. Since then I've had no other model.' The pond became Monet's most enduring motif, the water lilies the most celebrated flowers he ever painted. Monet's water lily paintings are shown here juxtaposed with contemporary photographs of plants and ponds and archival photographs of the painter and his famous gardens at Giverny.

Vivian Russell describes the making of the water garden, which, in contrast to the flower garden, was to be meditative and mysterious, in tune with the Japanese aesthetic. She reveals how Monet chose his water lilies from plants bred specially by Joseph Bory Latour-Marliac at his nursery near Bordeaux. Her superb photographs capturing the ephemeral beauty of the flowers, the way they appear to float on clouds and undulating rushes, portray the changing moods of the pond, complementing Monet's visions of Giverny.

Over 30 color photographs, 28 paintings and prints, and 14 archival photographs

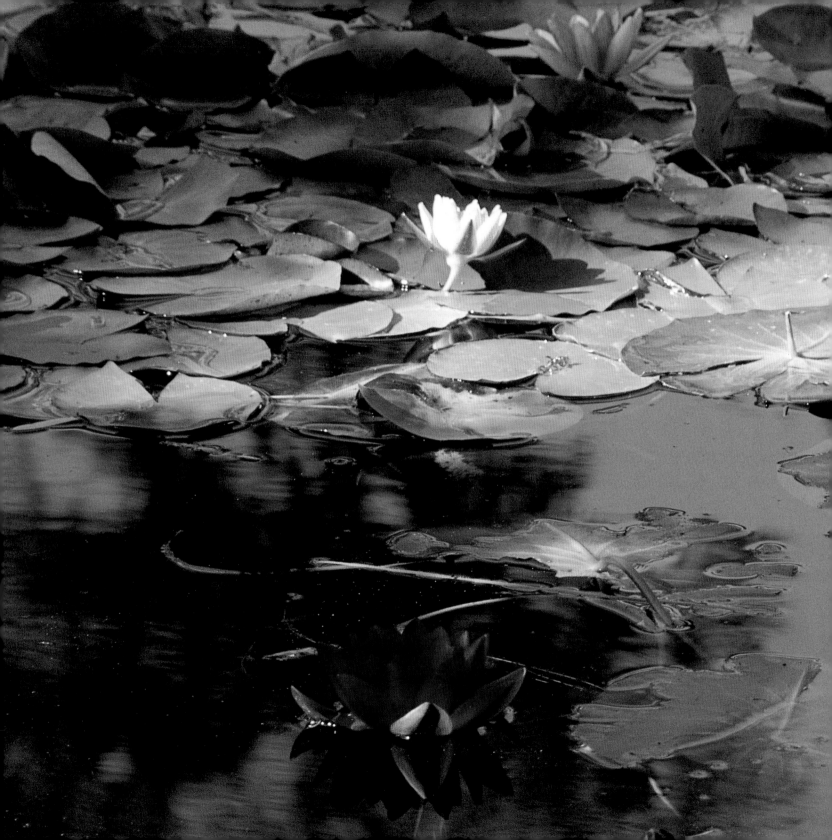

MONET'S WATER LILIES

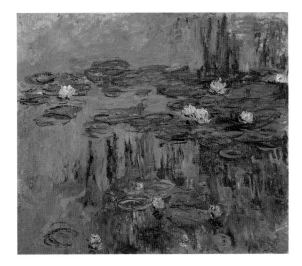

Vivian Russell

A Bulfinch Press Book
Little, Brown and Company
Boston • New York • Toronto • London

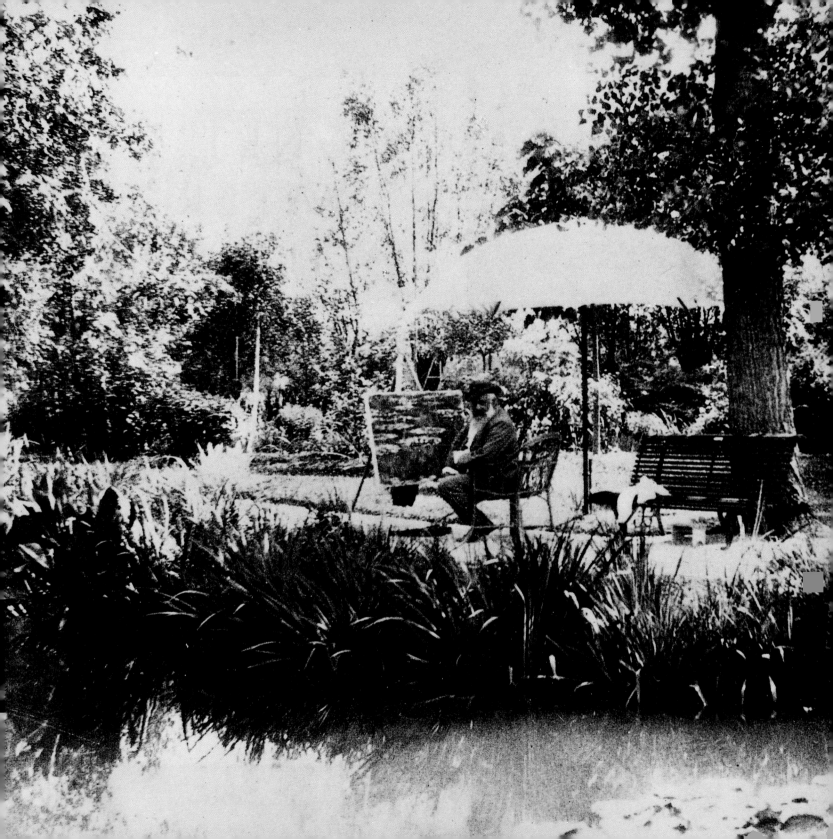

'The world longs to be seen: before there were eyes to see with, the eye of the water, the great, large eye of peaceful waters, watched flowers as they blossomed. And it is in that reflection – who would deny it! – that the world first became aware of its own beauty. In the same way, ever since Claude Monet looked at water lilies, the water lilies of the Ile de France are more beautiful, larger. They drift along our rivers with more leaves, more peacefully, as well behaved as images of Lotus children. I once read – I forget where – that in the gardens of the Orient, in order to make the flowers lovelier, and blossom more quickly, more profusely, with a clear confidence in their beauty, people showed their concern and love by placing two lamps and a mirror in front of a healthy stalk that held the promise of a young bloom. That way, the flower could admire itself even at night. Thus it had a neverending enjoyment of its own splendour.'*

Gaston Bachelard

Monet beside his pond, with its continuous hem of irises. On the easel is a painting from the 1904 Water Lilies series.

To my wise and generous friend,
Erica Schilling Hunningher,
who thought of and guided this book

MONET'S WATER LILIES

Copyright © 1998 by Frances Lincoln Limited
Text copyright © 1998 by Vivian Russell
Photographs copyright © 1998 by Vivian Russell
Paintings and archive photographs are credited on page 93

Monet's Water Lilies was produced by Frances Lincoln Limited, London

First North American Edition

ISBN 0-8212-2553-7

Library of Congress Catalog Card Number 98-66348

Bulfinch Press is an imprint and trademark of
Little, Brown and Company (Inc.)

Published simultaneously in Canada by
Little, Brown & Company (Canada) Limited

PRINTED AND BOUND IN HONG KONG

ENDPAPERS Green Reflections *(details) from the* Grandes Décorations
in the Orangerie
TITLE PAGE *Light dances on Monet's pond and (inset)* Water Lilies, *1915*
RIGHT Nymphaea *'Candidissima'*

Contents

PREFACE

NOTHING PREPARES YOU for the effect of seeing Monet's *Grandes Décorations* for the first time on the walls of the Orangerie in Paris. After you descend the stairs to enter the two elliptical rooms of the vast curving panels of water-lily paintings, you feel drawn into a magnetic field created by the hypnotic energy that radiates from them. What overwhelms you most in this silent, secluded dreamworld is the suspension of all movement, the evaporation of reality. As if caught in the eternal loop of an hourglass, time becomes timeless.

The experience is as breathtaking as entering a cathedral just as the sun clears a cloud and bursts through stained glass, and a spreading kaleidoscope of refracted light illuminates every particle of dust that hangs almost weightless and otherwise invisible in the vast emptiness of the hallowed atmosphere. In the vernacular of our modern age, the sense of awe is comparable to those epic cinematic moments when an audience sits spellbound before the dazzling visuals and sound of a celluloid universe. Whatever the idiom, it is the mystical power of light experienced as something divine that stirs us.

To achieve such wonder through the splendour of architecture or the technical wizardry of movie-making, in which literally hundreds of brains have participated, is one thing. For an old man to have done this alone with a brush, a palette and a canvas he could barely see transcends genius. How layer upon layer of oil paint, now dried and crusty, have produced such luminosity and radiance is absolutely incredible.

Monet's quixotic search to render the beauty and drama of nature drove him from the first moment he picked up his brushes. It pervades his work, from his glorious land-, sea- and riverscapes to his paintings of the microcosm of his garden pond. For the last thirty-three years of his life he peered into this little pool as intently as a scientist squints into a microscope to unlock universal mysteries.

You may not have been told that Monet painted the *Grandes Décorations* at a time of personal despair, bereavement and isolation, with the carnage of the First World War almost on his doorstep, but somehow you know. Nothing this noble could arise from anything less. These paintings were his response to desolation; his last chance, he knew, to fix for ever what he had learned from a life of sustained observation of a world he loved, as he saw it, as he admired it. Nature, like life, often tempestuous and cruel, is presented in all her restorative tranquillity and grace. Monet's final work is a *cri de coeur* of one man's faith in the redeeming power of art.

Detail from Morning with Willows, *one of Monet's 1920-26* Grandes Décorations *panels.*

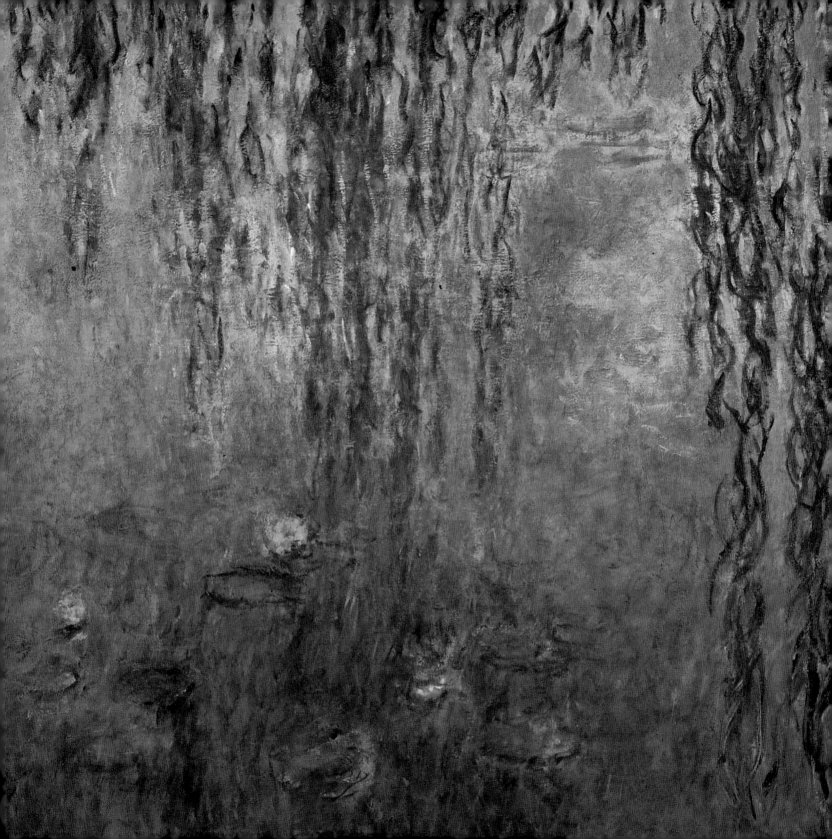

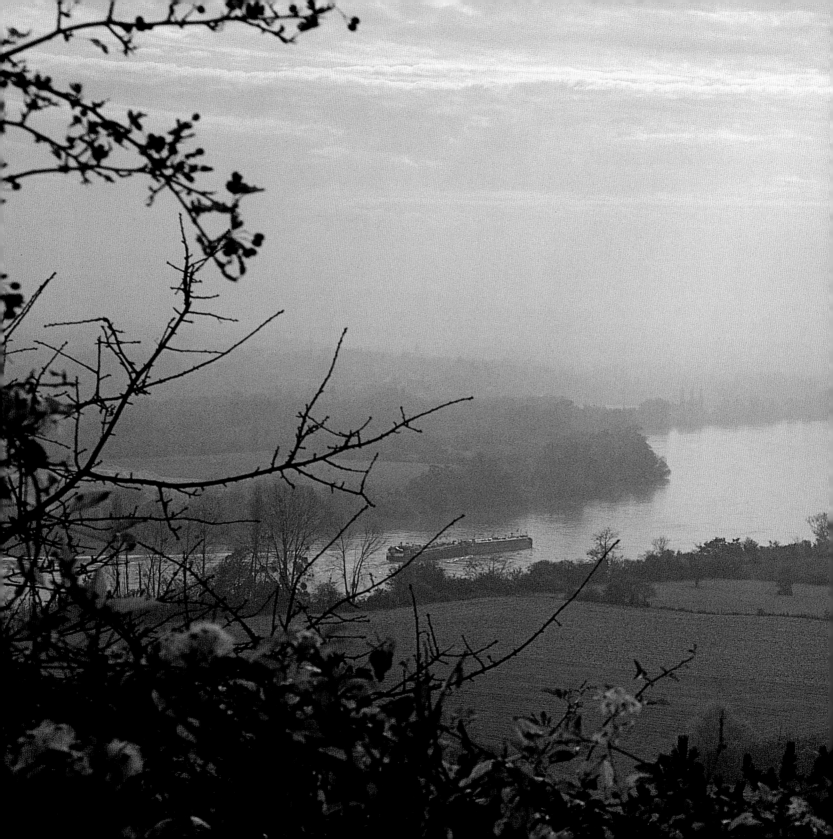

❖ 1840 - 89 ❖

THE EDUCATION
OF AN EYE

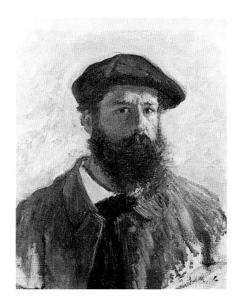

*'In Monet ... we enjoy a world of art, not just a vision,
and that world has the variety and space, and even some
of the ease, a world should have.'*

Clement Greenberg

*The long atmospheric sweep of the River Seine (opposite) made up so much of
Monet's 'world' he referred to it as 'my studio'. Monet, seen in a self-portrait of
1883 (above) at the age of forty-six, three years after settling at Giverny, where
in his garden pond he would find not so much a world as a universe.*

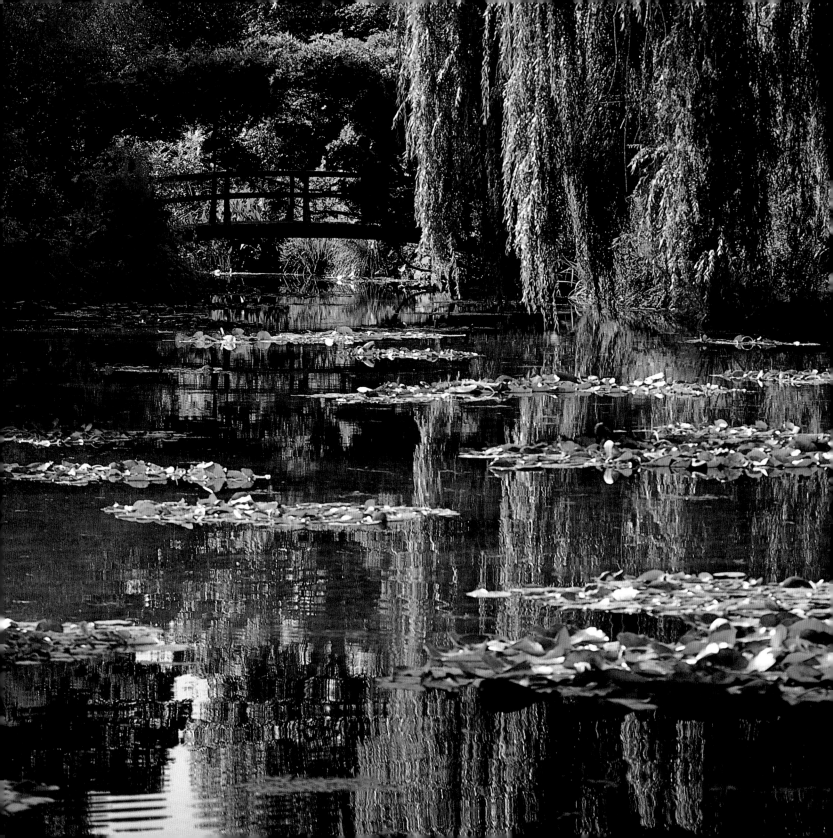

WHEN MONET embarked on the adventure of his water lilies at the age of fifty-three, he had spent the previous decade making his garden at Giverny into a kaleidoscope of flowers of unrivalled ingenuity. Only a few metres separated the garden from the narrow strip of land on the other side of the road where he would make his water garden. Taking only seconds to cross, the road was a deceptively small divide for what would turn out to be the frontier between the art of one century and that of the next. The water garden would inspire Monet to see and then paint in an entirely new way, in as revolutionary and as liberating a style as Impressionism had been fifty years before. Here he would abandon the conventions of perspective and horizon to explore space, illusion, light, meditation and reverie. It proved to be the key that unlocked the door to the world of twentieth-century art.

The strip of meadow of this 'Promised Land' consisted of an unprepossessing foreground, with a row of tall poplars forming an imposing background. Yellow flag irises grew in the marsh, native alder made a dense undergrowth, wild willow choked the banks of a small meandering stream colonized by native water lilies. Aquatic flora naturalized on ponds, and pools of water reflecting sky, clouds and overhanging trees, are not in themselves unusual. It took a painterly eye and the heart of an ardent gardener to make the ordinary extraordinary. Monet widened the stream into a pool, laced its banks with irises, honed the unkempt willow into a delicate and mysterious tree and adorned the water's surface with the exquisite water-lily hybrids that had just been created. His pond would become the most famous in the world and the water lily the most celebrated flower ever painted.

Painting and gardening were conduits for Monet's passion for beauty, which flowed through him like an electric current. His art was his compulsive, obsessive struggle to make paint the language of this infatuation. In his early years, he taught himself the skills and techniques that enabled him to express first what he 'saw' and then, as he matured, adding what he 'felt'. He never stopped painting – not even in his sleep, as he was always painting in his dreams. Even when cataracts clouded his vision, he painted with the inner eye that he compared to the inner ear the deaf Beethoven used to compose. It was only when he lost his capacity to 'feel', at the time of the death of his second wife, that he virtually stopped painting for several years.

Monet's horticultural genius was expressed in the two perfectly realized halves of his garden where he explored earth and water, the elemental themes essential to his art. The 'jungle of beauty' effect of his flower garden (above) is counterpointed by the pond, a garden of reflection spread on a tranquil mirror enclosed by a green backdrop (opposite).

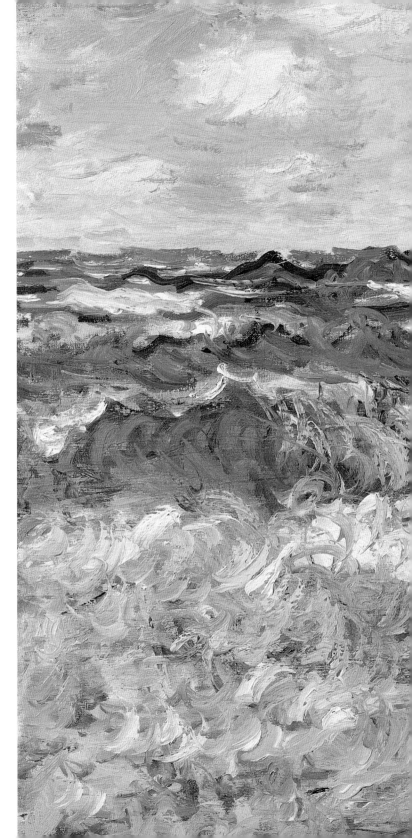

> *'To look out to sea, to face those two endless zones of water and sky and the mysterious edge at which they meet, is to face one of the strongest intimations of infinity. The feelings evoked by the sea are incomparable.'*

Andrew Forge

Light and water, the spectrum of his work, fascinated Monet most, and perhaps if he had lived another twenty years he would have found a way to paint only them, dispensing with mass and matter altogether. For his brilliant orchestration of these two themes he was dubbed 'Paganini of the rainbow' by the Belgian poet Georges Rodenbach. He admitted that he felt really well only when he was near the River Seine, as though that main artery of France somehow coursed through his veins too. He could never stay away from the sea for long without the old nostalgia for it beckoning him to return. 'I would always like to be before or under it', he wrote, 'and when I die, to be buried in a buoy.' Floating imagery pervaded his work: boats in the harbour, sailing boats at sea, studio boats on the river, breaking ice floes, reflected tulip heads bobbing on canals, rafts of water lilies suspended on the surface of his pond.

Monet's passion for light and water fill Sea Study, *painted in 1881, probably near Fécamp. 'Although Monet did not often paint an empty sea straight on, he was extremely susceptible to its majestic appeal and his lifelong relationship with the sea must have helped to shape the subject matter of the last twenty-five years of his life, the pond at Giverny.' (Andrew Forge)*

Monet's life was a journey which began and ended near the Seine. He was born in Paris in 1840 and at the age of five moved to Le Havre, where the great river empties into the English Channel. He was a rebel from the start. Bored in class, he doodled caricatures of his teachers in the margins of his school books. 'Never would I bend, even in my tender youth, to a rule. School always appeared to me like a prison, and I never could make up my mind to stay there, not even for four hours a day, when the sunshine was inviting, the sea smooth, and when it was such a joy to run about on the cliffs, in the free air, or to paddle around in the water.' When the painter Eugène Boudin introduced the fifteen-year-old truant to the joys of *plein air* painting, Monet became an artist by the sea and a rebel with a cause.

His cause, of course, became the Impressionist movement, whose credo was to liberate the artist from narrative, mythological, historical and religious painting conducted in a gloomy studio and release him into the great outdoors. This was made possible by the timely, pragmatic invention of the collapsible paint tube, which, in making paints transportable, gave painters mobility. No longer tethered to their studios, artists could set up their easels anywhere they chose, to celebrate nature and the everyday. 'Impressionism', declared Charles Stuckey in his speech to open the 1995 Monet Retrospective at the Art Institute of Chicago, 'brought painting down to earth. What the Impressionists set out to do was to make a picture of life on the fly as they knew it from day to day. They decided to embark on something that was totally absurd and impossible from the outset which was to try and bridge the discrepancy between how quickly we looked and how slowly we painted.'

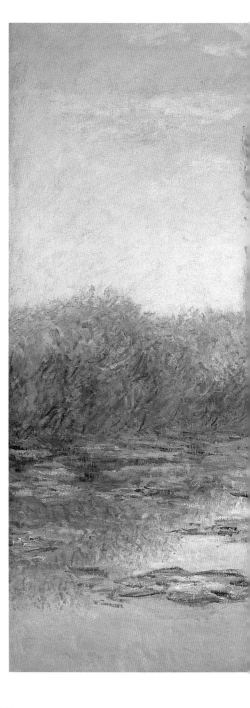

Water always reflected Monet's emotional states. Numb with grief, he first painted the ice breaking up into rafts on the barren, frozen River Seine in Floating Ice, *in the winter of 1880, following the death of his first wife Camille. It became a familiar visual theme, recurring as clouds floating across the sky and water-lily rafts spread out across a pond.*

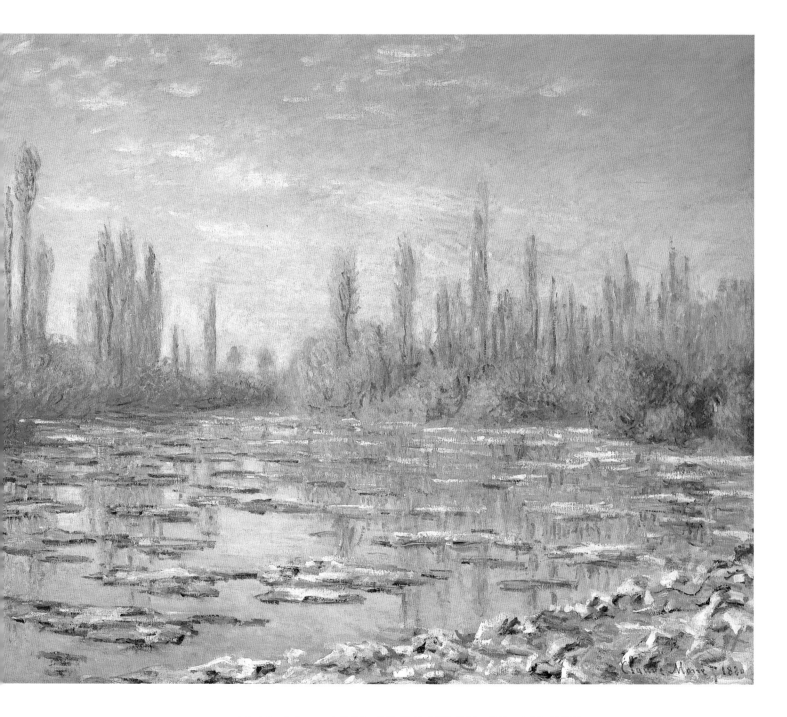

The challenge of seizing the moment, capturing the 'glimpse', became a race against the clock. As the sun moved across the sky, as the wind changed, as clouds bubbled up or scudded along, the painters had to keep up, and so they had to work out a way of painting that was, in a way, as fast as the speed of light. They had to be able to transcribe what was before them as swiftly as a secretary takes dictation. Thus did necessity become the mother of Impressionism. Monet and Renoir invented a visual shorthand of squiggles and scribblings, dashes and daubs in which a few blotches became a field of flowers, and crowds of people were represented as small black streaks.

Curiously enough it was not the art world but the literary world who best understood and appreciated the Impressionists. The poet Baudelaire compared their vision to that of a child who sees everything new, and wrote that as a group they could 'gorge themselves with devotion to their art'. In his novel *L'Oeuvre,* Emile Zola based the main character on Monet who, he wrote, 'wanted to capture, above all, the vivid, profound impression of the place, of the moment . . . to give the feeling, almost the emotion, of summer, autumn, morning, afternoon, evening.' 'The Impressionists have truth on their side,' noted Camille Pissarro, a prodigious letter writer; 'it's a healthy art based on sensations, and it's honest.' None of this impressed members of the art establishment; nor did they appreciate just what skill was needed to make a coherent picture solely from a seeming chaos of small strokes and dashes.

Andrew Forge, art historian at Yale University,

defined this honesty most eloquently: 'His view of the truth was condensed into the truth of light. Monet's eye was his first line of attack against the enemy, against everything that was stale, worn out, conventional, artificial – everything that dimmed or falsified the luster and sparkle of life. The bastion of these weary convictions was the Salon itself.' The judges of the jury of the state-sponsored Paris Salon, whose job it was to select paintings for their prestigious annual show, peered myopically into Monet's canvases, as if they were appraising the virtuoso brushwork of painters such as Delacroix. His stenographic style appeared as a mass of wildly brewed brushwork which they found infuriatingly incoherent. It would have coalesced into a perfect picture had they only stepped back, but such a concession was *hors de question*.

Moreover, the conservative critics considered the purely descriptive nature of the subject matter frivolous and unworthy of serious consideration. And by pouring scorn and derision on Monet's work, it remained unseen and unsold, condemning him and his fragile young family to a life of financial hardship and instability until he was fifty years old.

Painted in 1885, this study of The Cliffs at Etretat *is a perfect example of transient light. The morning sun is rising fast and shortly will be high enough to illuminate the whole rock. Monet might have had only seconds to record this fleeting effect.*

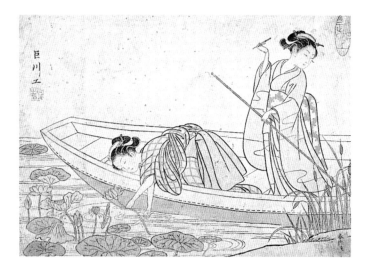

The Impressionists' aesthetic, and Monet's most of all, was guided not by laws dictated by the stuffy Salon but by the art of Japan. It had seduced Monet from the age of eighteen, when France had resumed trade relations and the rage for *japonaiserie* spread amongst the sophisticates of Paris. In their bold compositions, delicacy of colour, even in their calligraphic brushwork, the Japanese celebrated the moment, with a style that was simple, fresh and elegant. Several shops selling Japanese *objets d'art* and furniture opened in Paris, the greatest emporia being the five owned by Siegfried Bing. Monet was often to be found rummaging in the attics where Bing kept Japanese woodblock prints, although he could not afford to buy in the early years; he also went to all the exhibitions. His admiration for the Japanese aesthetic, with its inherent subtlety and suggestion – 'to evoke presence by means of shadow', as Monet told critic Roger Marx – endured throughout his life and he absorbed it ever more seamlessly into his own art.

1840-89 ✧ THE EDUCATION OF AN EYE

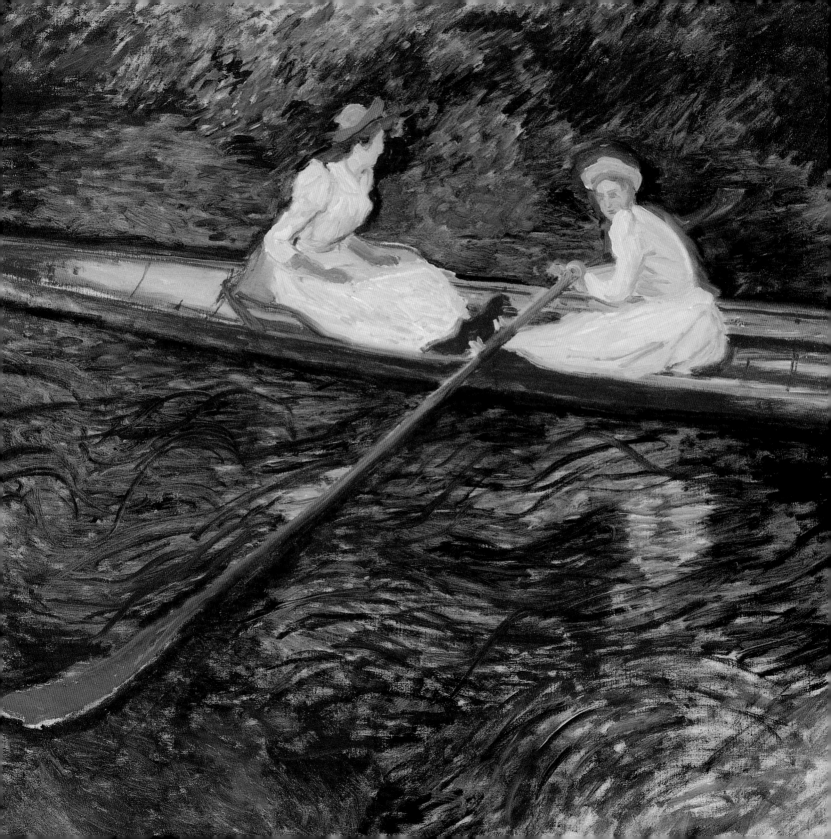

Entranced as he was by the calm, reflective philosophy of old Buddhist Japan, Monet was nonetheless very much a man of his era, his vernacular, his native soil and providentially his own backyard. 'His glance was quick, his brush was quick, and that as much as anything bonds him to our times. The images we live with ceaselessly accelerate,' continued Stuckey. In breathtaking landscapes, painted with breathless speed, he played Russian roulette with unpredictable weather. Windswept skies, rolling clouds and angry seas; blazing haystacks and fiery cathedrals; vertiginous cliffs and spinning cities; implausibly tall sunflowers – all expressed the vitality of nature and her elements. He painted 'water' in as many ways as it is possible to imagine it; he painted 'earth' in the pitilessness of towering jagged rock and in the vulnerability of its fragile flowers; he painted 'air', that intangible but by no means invisible atmosphere which envelops everything; and he illuminated it all with the 'fire' he seized as vigorously as Prometheus from the sun. If his paintings are so intensely alive and explode with colour and luminosity, it is because to Monet the world was radiant, intoxicating, thrilling.

In order to paint truthfully, he needed to experience the elements, to bond physically with them. 'Monet, he has muscles' was Cézanne's pithy appraisal of his athletically punishing approach to his art. A witness recounted an incident in 1867: 'It was cold enough to split rocks . . . We glimpsed a little heater, then an easel, then a gentleman swathed in three overcoats, with gloved hands, his face half frozen. It was Monsieur Monet studying an aspect of the snow. Art has its brave soldiers.' Twenty-five years later there was a similar scene, when he sat covered in snow in Norway, 'icicles',

he wrote, 'hanging off my beard like stalactites'. It did not matter how cold, how early in the day or uncomfortable the conditions, if only they would stay the same. His moods went up and down with the barometer: settled spells brought industrious euphoria, fickle weather drove him to despair. 'I follow nature without being able to seize it' was a characteristic refrain expressing his frustration.

Monet may have been the fastest painter of his time, but the 'effect' he was seeking to capture never lasted long enough for him to record all the detail, still less to complete the picture. Characteristically, Monet turned this into an advantage. Having taken so much trouble to reach a perfect spot, why paint just one fleeting light effect when, by bringing several canvases, he could record a progression of light falling on landscape and be painting all day? 'In the 1880s,' wrote the American painter and critic Theodore Robinson, 'anything that pleased him, no matter how transitory, he painted, regardless of the inability to go further than one painting. Now it is only a long entwined effort that satisfies him, and it must be an important motif, one that is sufficiently *entrainant* [captivating].' The concept of series painting, described by Andrew Forge as a style 'in which many images circle around a constant form and the work itself is the sum of all those images', was not new. The early nineteenth-century Japanese painter Hiroshige had done it in *100 Famous Views of Edo*, as had Constable, with his studies of clouds and skies in different weathers and times of day, and Courbet, who painted thirty variations of a crashing wave.

Monet tackled and worked on his motif the way a sculptor grapples and wields stone, honing it into

perfection. The idea of painting in series gave him the opportunity to study many permutations of the way light reflects off a given surface in a given season and time of day. The variations of this theme were infinite. His explorations took him to all the coasts of France – campaigns that could keep him away for months at a time, always alone. He would not rest until he had taken each experiment as far as possible and when he moved on it was only to find a new set of problems to solve – a new motif which required him to devise new techniques. Much of his rage and his frustration stemmed from the struggle to close the gap between what he beheld in his mind's eye and his ability to transcribe it on to canvas. It was always, tantalizingly, just out of reach. Monet would invariably return to motifs days, weeks, months, even years later. Only the knowledge that he could return made it possible for him to leave them at all.

In 1889, Monet went on an arduous spring painting campaign to the Creuse, whose climatic vicissitudes nearly drove him mad. The cold, he said, was unbearable, his chapped hands were permanently inside

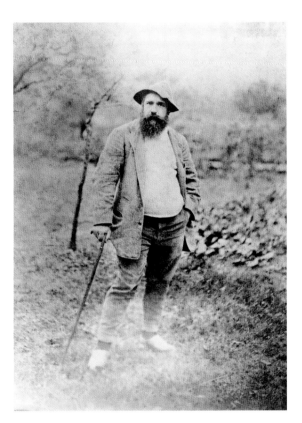

Monet in his Giverny garden around 1887, when his flower garden was well advanced and he was still doing the work on it himself with only part-time help.

glycerine gloves. As the river rose and fell with the rain, it changed colour almost every day, and blinding bursts of sunshine flared off its surface like 'sequins and diamonds'. When spring arrived virtually overnight, the buds burst on the oak he was painting, and the leaves unfurled. With five unfinished canvases of the oak in the ravine, and three more 'in which the oak tree plays the whole role', Monet hired two men with ladders to strip every leaf off the tree – a preposterous perversion of nature and the Impressionist philosophy.

For his prolonged braving of the elements Monet was rewarded with a bad back, digestive troubles and rheumatism. 'I must give up defying all kinds of weather', he wrote upon his return, telling friends he was giving up landscape painting. From then on Monet would paint in more salubrious conditions – a suite of rooms at the Savoy Hotel for his London series, a cramped but protected perch in a milliner's shop across from Rouen Cathedral, a hut for his Pourville seascapes. But he would find the most sheltered and ideal setting of all in the most unexpected place: his garden.

Monet's passion for gardening had evolved alongside his art, fostered by his friend and patron, the wealthy painter Gustave Caillebotte, with whom he also shared a love of water. Caillebotte was a skilled gardener and was as generous with seeds, cuttings and advice as he was in response to Monet's frequent requests for small loans. For Monet, his garden was a haven, and his love of the soil was innate and true. In the years before he became successful it was a refuge from the worry of poverty, from the anxious challenge of his painting and the critics who ridiculed and denigrated it. Failure to meet demands from irate landlords for rent often led to evictions, but no matter how short a time he stayed, Monet gardened wherever he lived. There was always a patch of sunflowers or dahlias, a pot-filled courtyard or something green growing in those famous blue porcelain pots he bought in Holland in 1871, which appear in many of his early garden paintings. He spent quiet Sundays gardening, or painting his wife Camille and their baby son Jean in the garden – scenes of lyrical domesticity Manet and Renoir found so charming that they set up their easels in his garden to record them.

When, after Camille's death, he settled in Giverny, with his two children, and Alice Hoschedé and her six children, Monet devoted his early years there to converting the garden, then an apple orchard, into a garden of colour. He did this by using simple flowers in sophisticated ways. It was a novelty for France, entirely unique – as indeed was every expression of the aesthetic aspects of Monet's life. His style was his own: no other house was decorated like his, no one dressed like him – no one even looked like him – and this inimitable originality is what makes Giverny a paradise for pilgrims today.

Monet took the practice of massed bedding, the staple of French horticulture so dear to every French gardener's heart, and replaced the brash little annuals with cottage garden flowers, which he placed into the layout of the potager. Mass plantings of irises, sunflowers, dahlias and campanulas, arranged side by side like swatches on a palette, made an impressionistic, geometric flowery grid. 'The garden is divided into tidy "squares" like any truck garden of Grenelle or Gennevilliers,' observed the critic Arsène Alexandre.

The family (above) under the lime trees at Giverny in June 1893. Seated, from left to right: Michel Monet, Jean Monet, Suzanne Hoschedé and Alice Monet. Claude Monet, in a beret, stands by Suzanne's son Jimmy Butler talking to Paul Durand-Ruel. The Grande Allée (opposite) as it is today in its late summer glory. The famous blue pots are affectionate reminders of Monet's earlier gardens.

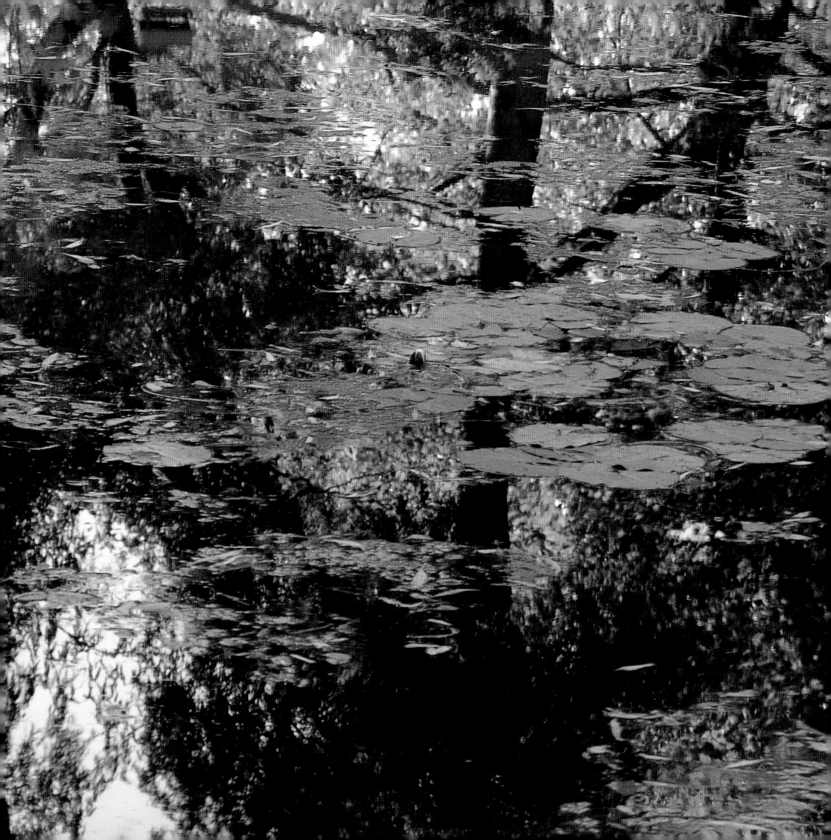

'Do you not like the [Dutch] bulb fields? . . . I find them splendid and when the flowers in blossom are picked and thrown into . . . the canals one suddenly sees yellow patches floating like coloured rafts in the reflection of the blue sky . . .'

Claude Monet

Having mastered the art of the flower garden Monet took up the challenge of gardening on and around water. With its tall, bold flashing flowers his earthbound garden contained an array of shapes, heights and colours. The smooth surface of his floating garden, however, supported only one kind of flower and one shape of leaf; the flowers, far from thrusting upwards, basked in their own reflection, and the leaves served as anchor and foil to the ephemeral harmonies of coloured light on water. Monet was slow to recognize the leitmotifs of his painting in this new scenario, in which sweeps of sky, sea and sunlight, and luxuriant garden bouquets, were unexpectedly condensed in a very small pool. 'It took me a long time to understand my water lilies,' he explained many years later. 'I had planted them for the pure pleasure of it, and I grew them without thinking of painting them . . . you don't absorb a landscape in a day . . . And then, all of a sudden, I had the revelation of the enchantment of my pond. I took up my palette.'

When Monet created his pond, the bright, breezy skies and Atlantic rollers of his seascapes ceded to these tranquil harmonies. And although the waters were comparatively less troubled, the process of painting them was no less troublesome.

1840-89 ✦ THE EDUCATION OF AN EYE

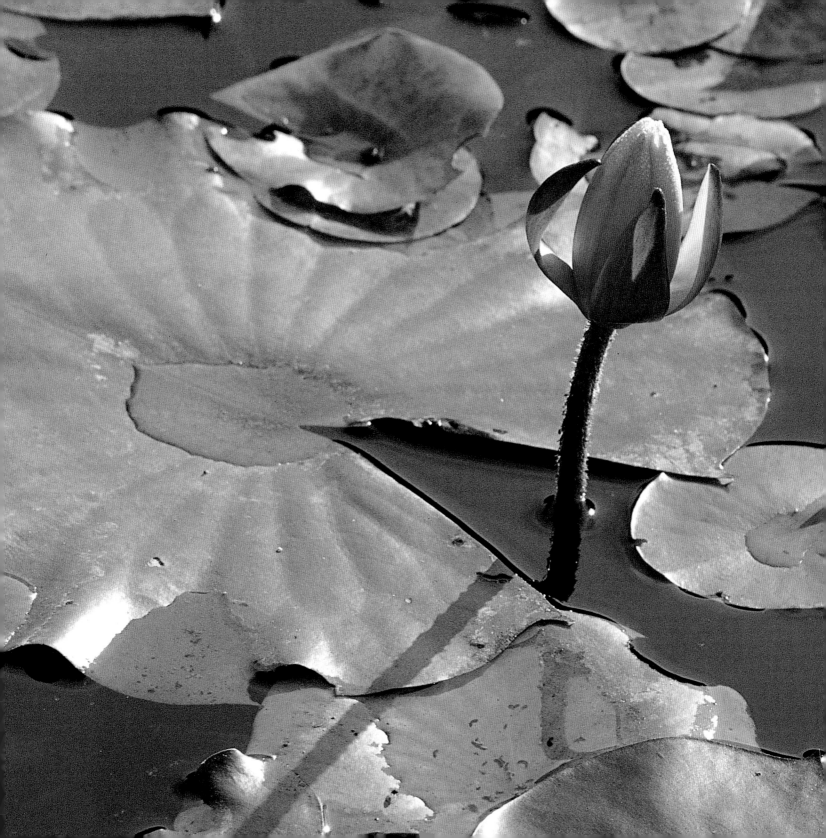

GENESIS OF THE WATER GARDEN

'Over the last few years . . . it has been recognized how monotonous a pond without plants would look in a garden . . . in order to complete the ornamental harmony, the display of terrestrial marvels must be combined with aquatic ones.'

Joseph Bory Latour-Marliac

The hybridizing maestro of aquatic marvels, Joseph Bory Latour-Marliac (above), c.1900, and (opposite) one of his progeny in embryo form. An air of expectation attended the imminent breaking of each new water-lily bud.

IN THE FROZEN WINTER that followed the death of his first wife Camille, in 1879, Monet had begun his *Floating Ice*, which, in the striking compositional similarity of the ice floes to floating rafts, more than anything anticipated his water-lily paintings. At the same time, a fellow countryman, Joseph Bory Latour-Marliac, living by another river in south-west France, was also dreaming of beautiful rafts upon the water, composed not of ice but of exotic water lilies flourishing under northern skies. As he dropped his newly fertilized seeds into little pots of mud to germinate, never in his wildest dreams could he have imagined what significance this simple procedure would have on the course of art, nor how the progeny born of a muddy womb would appeal to the sophisticated eye of an aesthete living a thousand miles away. The paintings they inspired would be, to borrow Paul Signac's phrase describing Renoir's earthy palette, 'hymns to the glory of mud'. Still less could Latour-Marliac have foreseen how, forty years on, his water lilies would become a symbol of peace marking the end of a long and terrible war that would blight Europe for ever, just as the field poppy would represent the blood-soaked battlefields upon which it was fought.

The journey these water lilies made from Latour-Marliac's muddy pots to the bottom of Monet's pond seems almost predestined, as the paths of the master of *plein air* painting and the champion of open-air hybridizing would cross at the same time, when their pioneering work would be recognized, at the 1889 Exposition Universelle de Paris. This was the world fair that boasted the newly completed Eiffel Tower and showed off the glorious achievements of La Belle France in the Champ de Mars pavilion at its feet.

Included were three of Monet's paintings in one part of the show, and Latour-Marliac's new hybrid water lilies in another.

The water lilies were displayed on a little river near by in the Trocadero for the six-month duration of the Exposition. Monet's descendants believe he saw the water lilies there, probably in the company of his best gardening chums, the garden-mad writer Octave Mirbeau, who was covering the Exposition, and Caillebotte, as the three of them canvassed flower shows the way other men go fishing. Monet attended the inaugural dinner for the Exposition and was in Paris for another few days hanging his joint show with Rodin at the Georges Petit Gallery. This exhibition, together with the display of a few paintings for sale at Theo Van Gogh's gallery, timed to coincide with the Exposition, marked the point in Monet's life when his work finally began to sell – concluding the long sad chapter of his hard-luck story. Years of penury had made a shrewd businessman of him and Monet went on to become a wealthy man. Money was never a problem when it came to his garden.

Joseph Bory Latour-Marliac was born in 1830, into a landowning family of amateur and distinguished botanists. Although he studied law in Paris, his first love was natural history, and he returned to Temple sur Lot near Bordeaux after the 1848 revolution to help his elderly father manage the family's properties and supervise their plum orchards. He lived in a simple house on a property exceptionally rich in water, with a stream and at least thirty natural springs. A passionate plantsman, he became renowned for his experimental bamboos, many of which he introduced to French soil.

He subscribed to expeditions to China, and developed a network of contacts with botanists and horticultural societies all over the world through the Linnaean Society of Brussels, of which he became a member.

Latour-Marliac was only twenty-four when an article that was to change his life appeared in the Belgian magazine *Le Jardin Fleuriste*. It was by Monsieur Charles Lemaire, registering his excitement on the arrival of a glorious display of tropical water lilies at the Jardin des Plantes in Paris. He regretted they could not be acclimatized to northern climes and grown outdoors: 'Would it not be beautiful to obtain a rare, new variety, resulting for example from the crossing of our [Nymphaea] alba with the blue or red flowering nymphaeas?' he asked. 'What a sight it would be in future – a vast sheet of water where freely grow together, and also flower *N. coerulia* [sic], *N. scutifolia*, *N. dentata*, *N. lotus*, *N. gigantea*, *N. gracilis*, *N. odorata*, *N. pygmae*, *N. ampla*, etc.; the Victoria regia and cruziana etc., all of them with ample floating or hardly emerging foliage, with large white, blue, red, pink, yellow flowers, . . . tell me, is there in the world a sight more grandiose, more admirable, more attractive?' This exotic vision caught Latour-Marliac's imagination. 'Although I am a passionate admirer of all the beauties of the garden,' he wrote later, 'the flora of the water has always been my favourite study; and so it came to pass that, greatly encouraged by the wonderful results which attended the hybridization of a host of other special subjects, I resolved to experiment in a similar manner with the Nymphaeas.'

At the time, only the hardy wild water lilies were available to adorn European water gardens. These were the yellow *Nuphar lutea* and the native double white water lily, *Nymphaea alba*, that to Latour-Marliac were the 'principal objects of decoration in aquatic flowers – very pretty it is true but too much alike to excite any violent rapture over their cultivation.' His dream was to fuse the hardiness and long-flowering characteristics of the hardy species of water lilies with the beauty, large flowers and lovely colours of those from more temperate, even tropical zones, combining the best of both. Using his international contacts, Latour-Marliac began collecting seeds and rhizomes from species water lilies from many

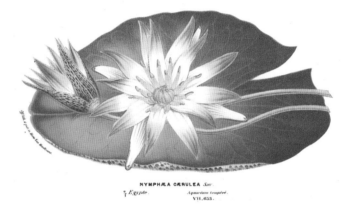

NYMPHÆA CÆRULEA *Sav*
⁴⁄₇ *Egypte.* *Aquarium tempéré.*
VII.653.

A lithograph of the Egyptian blue water lily, Nymphaea caerulea. *A symbol of resurrection in the East, it was most unaccommodating in the West and resisted Latour-Marliac's attempts to marry it with the hardy water lilies to produce a hardy blue. Nor could Monet persuade it to acclimatize in a special cement basin he built in his pond.*

countries, including Sweden, Mexico, America, Egypt, South Africa and India, and to cross them. For years his experiments failed but he persisted, as doggedly determined as that other visionary trying to transcribe nature with paint.

Latour-Marliac finally produced his first hybrid in 1877. It was discussed in horticultural journals and soon drew the attention of the editor of the Royal Horticultural Society magazine *The Garden*, William Robinson. In his book *The English Flower Garden,* one edition of which he dedicated to Latour-Marliac, Robinson provides a *coup d'oeil* into the hybridizer's struggles. 'I noticed at the time that the French and continental papers seemed inclined to say nothing about this good man. I heard that he lived in a remote part of the south of France. I resolved to go and see him. I found a very simple, straight sort of man . . . You could not think of a simpler beginning: in his little garden among a few old pots and pans which people usually throw away. His wife told me they never got any result for ten years, when one day they saw a red Water-Lily appear, and with such simple materials it is not easy to imagine how he succeeded. Such was the beginning, and little by little we got the finest lot of hybrids ever raised, not only for people with lakes and rivers, but also for people with small gardens.' Robinson

promoted these new hybrids as if they were his own, as indeed one of them was, *Nymphaea* 'Robinsoniana', named after him by a grateful Latour-Marliac, who also flattered other journalists across Europe and America in this way; they responded with columns of praise, creating an instant demand for their eponymous hybrids.

Latour-Marliac's intimations that he wanted to cross the tropical water lilies with the hardy species have led to assumptions that he succeeded and he did nothing to clear the confusion between what he hoped for and what he actually achieved, which was to successfully cross the hardy northern-hemisphere species with hardy species from more temperate zones, tolerant of low light and temperature. To be fair, Latour-Marliac did not know his dream was genetically impossible and never gave up trying. In 1888, still hopeful of crossing hardy with exotic, he described how he went about it in an article for *The Garden*. By using, he wrote, '*Nymphaea alba*, indigenous to Europe, *N. pygmaea alba* of Northern Asia; *N. odorata alba*, from North America; *N. odorata rosea*, also from North America (the Cape Cod Waterlily)' as the seed parents, i.e. the mother plants, and crossing each with the pollen of a father plant 'originated in the tropics or thereabouts, such as the Indian *N. rubra*,

This statue of Latour-Marliac marks the spot of his first experiments. He figured out how to select and mix pollen and nectar during the reproductive cycle of a water lily before anyone else did. One of his earliest successes was the exceptionally large Nymphaea 'Marliacea Chromatella' *(above), long and free flowering, described by him as 'producing a powerful ornamental effect', which Monet was quick to make the most of.*

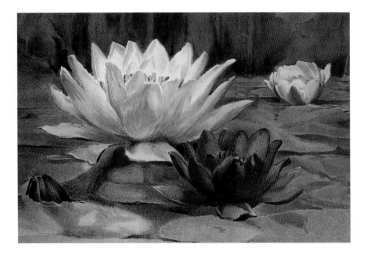

N. *devoniensis*, N. *flava* from Florida, N. *mexicana* from Mexico', he produced hybrids which 'having inherited from their paternal side the richest shade of colour, have been endowed by their female progenitors with a very hardy constitution . . .' His most cherished dream was to marry the hardy Europeans with the beautiful blue Cynaea group, for example, of which Monet's N. *zanzibariensis* was one, but to this day, no hardy blue water lily exists. His early hybrids were the N. 'Marliacea' and N. *odorata* series, which appeared intermittently during the late 1870s and 1880s, before he formally introduced them to the world during the 1889 Exposition Universelle.

'In the year 1889, the Universal Exhibition was held at Paris, and my small collection of the above-named hybrids timidly took the road to the metropolis, to see if possibly they might attract some notice from amateurs in the midst of the plant-wonders there,' wrote Latour-Marliac of the moment he pushed his protégés on to the stage. 'Their graceful elegance, however, was appreciated,

'We owe a deep debt of gratitude to M. Latour-Marliac, who has given us an addition to our hardy garden flora which cannot be over-estimated. He has added the large and noble forms and the soft and lovely colour of the Eastern Water Lilies to the garden waters of Northern countries . . . The splendid beauty of these plants will lead people to think of true and artistic ways of adorning garden waters.'

William Robinson

A lithograph (left) from an 1893 issue of the RHS magazine The Garden *shows three of the hybrids,* Nymphaea *'Marliacea Carnea', N. 'Marliacea Ignea' and N. 'Marliacea Chromatella', that Monet would have seen at the Exposition Universelle in 1889. He was attracted by the remarkable variation in colour, petals and leaves of hybrid water lilies (right), seen at the Courson Flower Show near Paris, a century after Monet first saw them on display.*

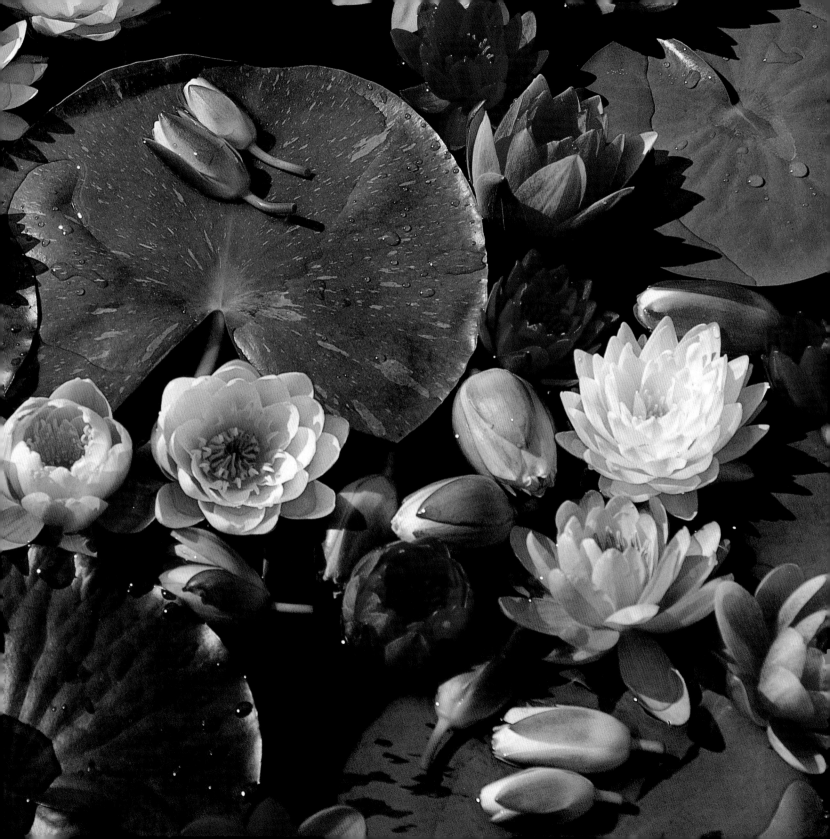

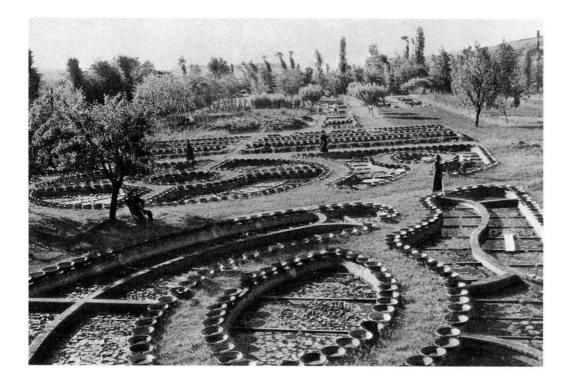

A 1912 view (left) of Latour-Marliac's nursery, showing the water-lily pools, partitioned by variety. The 'saving' pots (opposite) lining the pool sides were used to save the side eyes, which were removed from the water-lily rhizomes whilst the orders were packed, for potting up later. They now serve a purely decorative function.
OVERLEAF Some of the hybrids still grow in the pools: (clockwise from top left) Nymphaea 'Colossea' (1901), N. 'Newton' (1910), N. 'Conqueror' (1910), N. 'Comanche' (1908); and (full page) N. 'Sulphurea grandiflora' (1888).

and they came back radiant with the distinction of a first prize. What a change has taken place since then! And with how much more assurance would that first collection have made the journey to Paris if they had undertaken it in company with the splendid generation which has since made its appearance!'

Latour-Marliac's claim that their 'vitality allows them to survive for a long time out of water, and to survive long voyages' was unintentionally tested and confirmed when the collection despatched to Paris was lost on the railway and had to be replaced. The original shipment turned up a month later and, convinced they would be dead, Latour-Marliac ordered they be returned on a slow train. When they arrived back, he was 'utterly

astonished to see them in good order and covered with shoots, and little the worse for being so long boxed up'.

Their hardiness surprised everyone. Latour-Marliac said they were 'gifted with an absolute robustness that does not fear the bleak north winds, nor a prolonged stay under ice.' Robinson proclaimed 'they were as hardy as the great Water Dock by the lake side'. Nor were they delicate or demanding with respect to their culture, soil, or kind of container. They were accessible to anyone with a pond or a pool in their garden. 'If neither ponds nor tanks are available,' explained Robinson, 'these Water-lilies can still be easily grown, for, as M. Latour-Marliac says, they can like Diogenes, content themselves in a tub.' All they required was still water

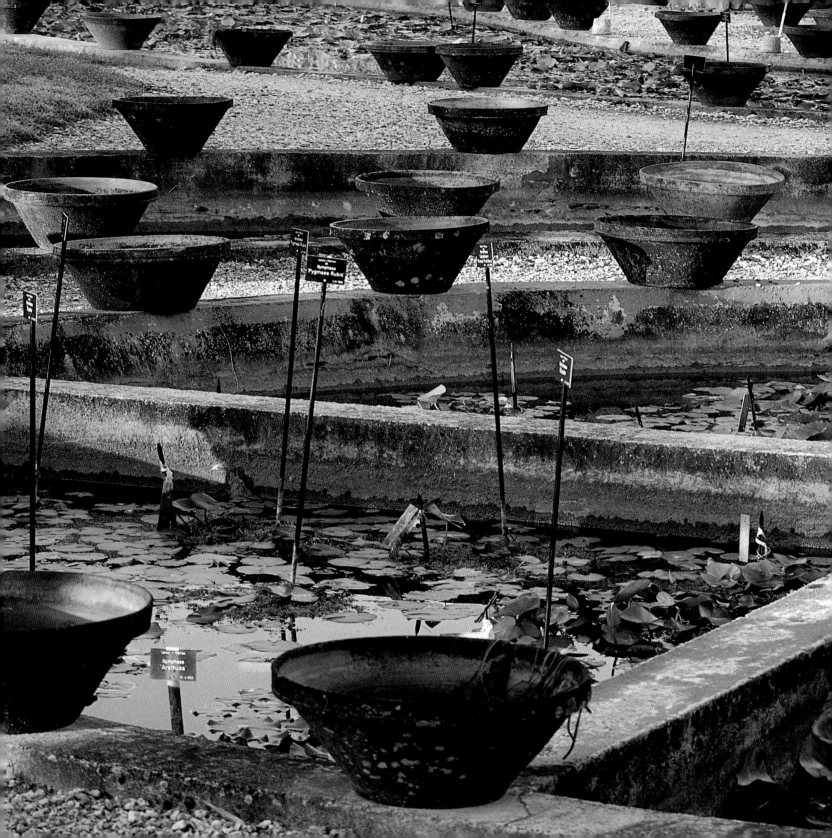

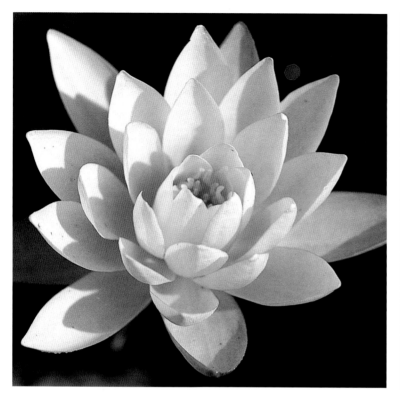
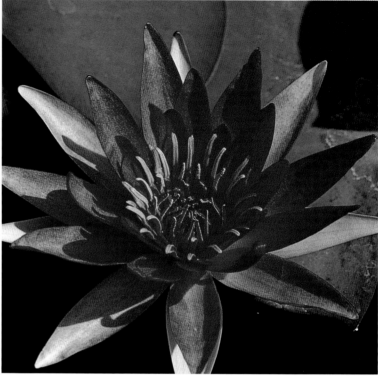
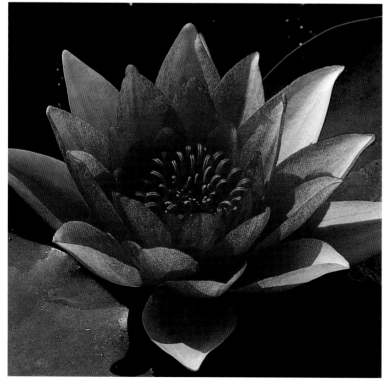
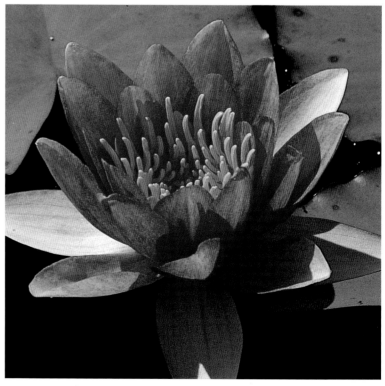

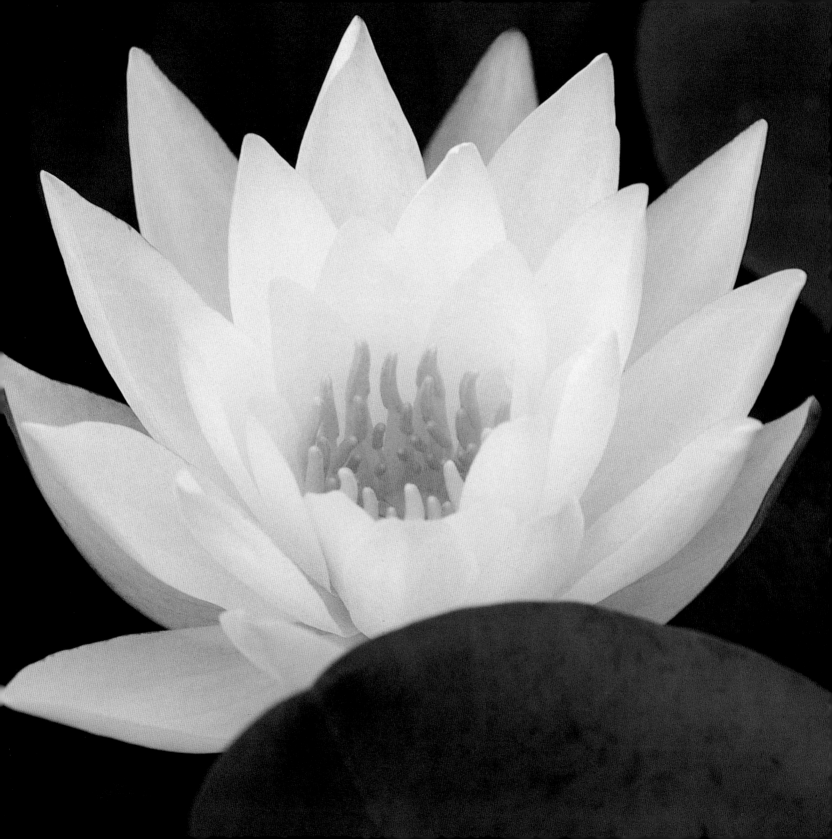

and their roots in mud. Latour-Marliac sold them from his nursery, along with his collection of bamboos, many of the aquatics Monet would order, as well as sub-tropical and exotic plants such as lotuses. Once the technique of producing these hybrids had been perfected, new ones followed, and by the time Monet began his water garden there were fifteen hybrids to choose from. When Monet recalled 'taking a catalogue and choosing them *'au petit bonheur* [to my heart's content]', he was indeed spoiled for choice.

After the Exposition Universelle of 1889, Monet, still recovering from the mental agonies and physical wear and tear of his Creuse campaign, curbed his artistic wanderlust. He pottered around Giverny painting local motifs, all in serial form: haystacks, meadows, poppy fields, poplars, undulating grasses in the River Epte and islets on the Seine, all only minutes from his front door. Artistically focused on Giverny, he also became domestically focused, as a sequence of important events enabled him to put his house 'in order'. In 1890 his Giverny home, which he had been renting, was put up for sale and he was able to buy it, four days after his fiftieth birthday on 14 November. Alice's estranged husband, Ernest Hoschedé, died a few months later from gout, leaving Monet free to legalize his relationship with her, which the villagers had been whispering about for years, and to give away his step-daughter and favourite model Suzanne Hoschedé – 'Sukey' – on 20 July 1892, a few days after his own wedding.

Now that the Giverny garden was permanently his, and he had the wherewithal to finance it, he proceeded to make major capital improvements, which included building two greenhouses and hiring a head gardener,

Félix Breuil – the son of Octave Mirbeau's father's gardener – and a team of at least four gardeners to look after the ever more diverse and complicated horticultural enterprise. The expansion of the garden brought a flurry of letters between Caillebotte, Mirbeau and Monet, swapping seeds and plants, dispensing advice on greenhouses, reporting on flower shows. Returning from the 1891 Concours d'Exposition de Paris, where Latour-Marliac won the Grande Medaille d'Or and two Certificats de Mérite, Monet, in a letter dated 1 May, reported to Caillebotte that he had seen '*des choses admirables* [some admirable things]', which would have included many more of Monsieur Latour-Marliac's astonishing hybrids.

In 1893, the year in which Monet began subscribing to the *Revue Horticole*, which carried articles by Latour-Marliac about his new hybrids, Monet acquired the strip of land that would become the water garden. At the time he bought the land, on 5 February, he was taking advantage of the hard winter and had returned to painting ice floes. He requested planning permission to divert a tiny arm of the Epte, a simple stream called the Ru, which ran through the land and which was to be turned and redirected into the pond and out again – like a loop. Then he went off to Rouen to continue his Cathedral series. But while he was away Alice reported that the locals had objected, suspicious that he might introduce bizarre and exotic plants that would poison the stream their cattle drank from. This infuriated Monet and he ordered Alice to cancel the whole project, but July found him writing a placating letter to the *préfet* outlining his reasons for the pond, for the 'pleasure of the eye' and 'motifs to paint' and reassuring him that he

was going to grow only aquatic plants that were native to the river, like water lilies, reeds, and irises of different varieties which grew there anyway. A journalist friend intervened, Mirbeau also wrote a letter, and a week later authorization was granted.

Creating a water garden was for Monet something his step-son Jean-Pierre Hoschedé recounted as the 'realization of a dream he had conceived and nurtured for a long time'. Exactly what kind of water garden Monet had in mind we do not know; but we do know that, coincidentally, only four days before he bought the land, on 1 February 1893 Monet went to an exhibition of prints by Hiroshige and Utamaro, on loan from Siegfried Bing to his dealer Durand-Ruel, in Paris. When he left the exhibition, wrote Daniel Wildenstein in his *catalogue raisonné*, he took away 'images of still waters, exotic plants, miniature bamboo forests, and Japanese bridges'.

The water garden has often been compared to a Japanese garden, by virtue of its Japanese-style bridge, willows and bamboos; Mr Hayashi, Monet's friend, frequent visitor and dealer in woodblock prints, insisted the garden was modelled on a Japanese one. But Monet himself said that apart from the bridge he called '*genre Japonais* [in the Japanese style]' this was not his intention. After all, the water garden has none of the distinctive features of a traditional Japanese garden: there are no rocks, waterfalls or stepping stones; no tea pavilions, sculpted shrubs or raked sand – and the bridge was not even painted the typical vermilion.

What Monet's water garden does resemble, though, are the tamed landscapes of Hiroshige. The visual accents are all there.

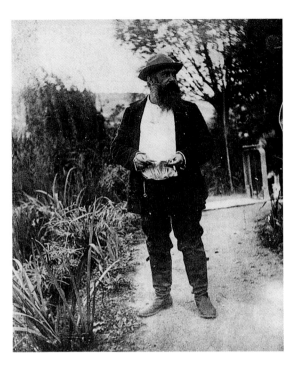

Monet standing by his iris-lined pond (above), in 1895, when the water garden was in its early stages. His mind's eye, however, had singled out elements of Hiroshige's landscapes (overleaf left) which, as an admirer of the Japanese power of suggestion, he used 'to evoke the whole by means of a fragment'. In Monet's pond (overleaf right), Hiroshige's visual elements are brought together. (Clockwise from top left) Wisteria and a drum bridge; irises on the poolside forming a curtain through which appear floating lotuses that Monet replaced with water lilies; a bridge spanning a lake animated by boats and overhanging trees; bands of clouds, trees reflected in the water and an island which Monet also built in his pond; long fronds of trailing weeping willow – are all easily recognizable visual parallels; and finally, a landscape with a symbolic rather than a visual likeness depicting a 'mirror pond' named for the Kyoto nobleman who saw the face of his beloved traced in the water, and a 'reflection bridge' from the legend of the woman who drowned herself after seeing a disturbing reflection in the water.

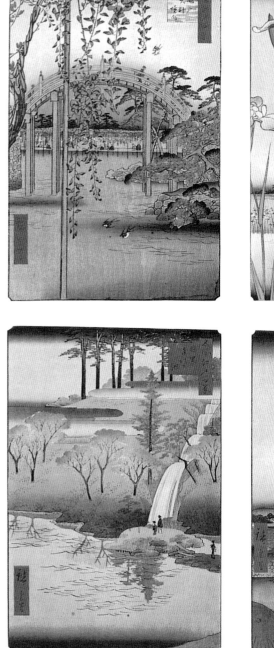

1889-1901 ❖ GENESIS OF THE WATER GARDEN

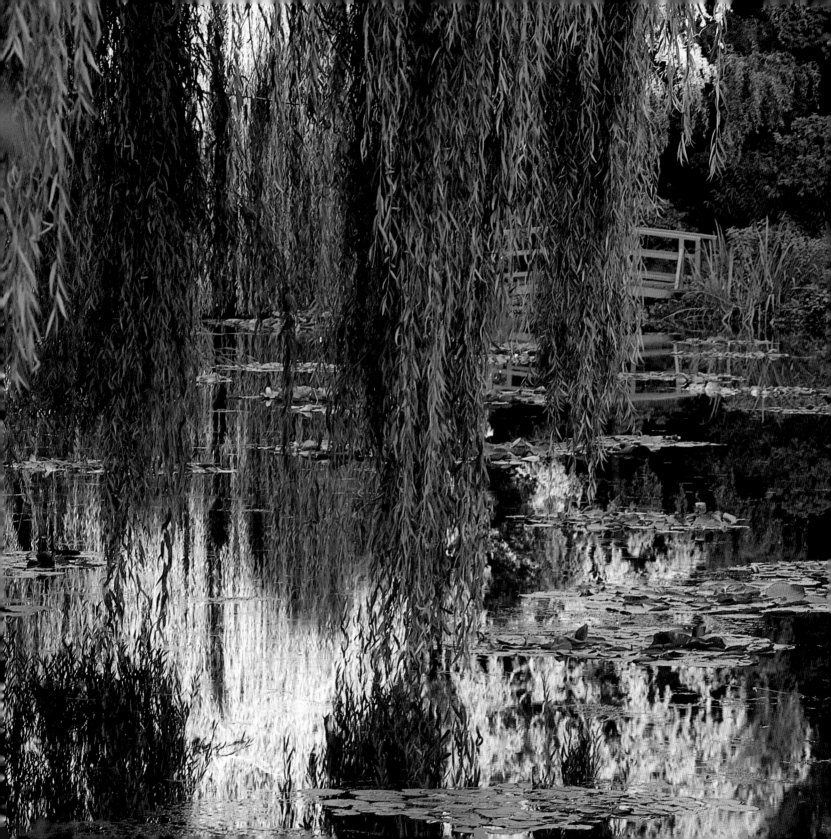

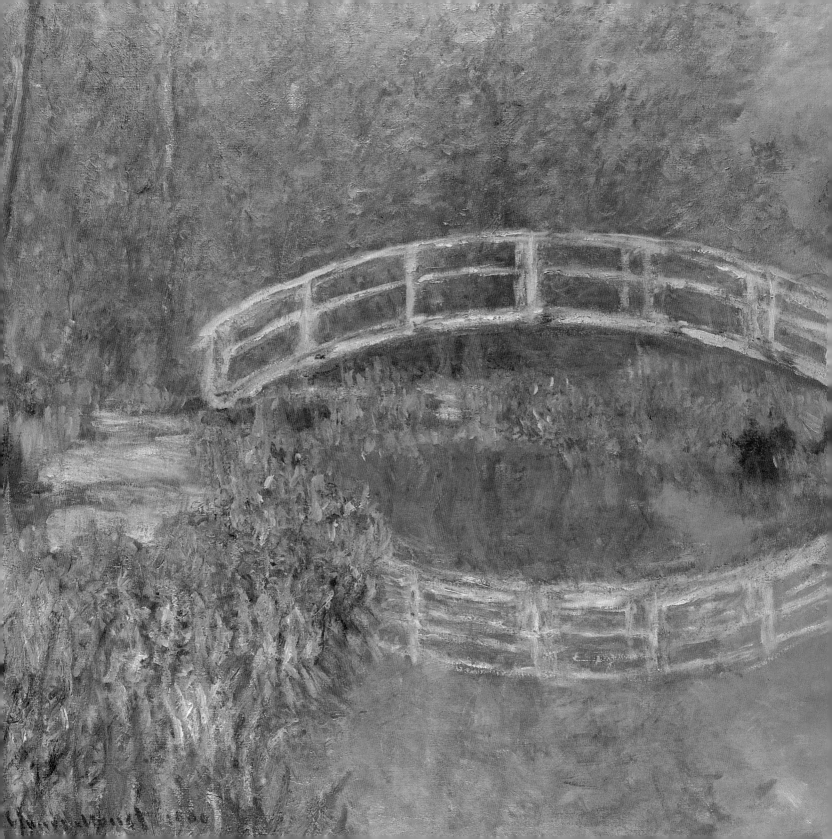

When Monet first painted the water garden in January 1895, it was contained within a nutshell, restricted by the small amount of land he was able to buy and rent. Unfortunately the painting survives only in a black-and-white photograph, depicting a meandering little river with the arc of the bridge over it, so characterless it could be anywhere. But following the deaths of fellow Impressionist Berthe Morisot, whose work he loved, and of his dear friend Caillebotte the year before, for his next two pictures Monet used the same blue and gold palette he had used for his sunny *The Artist's Garden at Vétheuil*, painted in 1881. Caillebotte had been working on a decorative ensemble of his orchids to use as panels in his dining-room, and Morisot had painted a large decorative mural in the mid 1880s that Monet saw exhibited in her Retrospective, which he helped to organize the following year. Perhaps the idea of doing one himself on a much larger scale than the numerous small flower panels he had done for Durand-Ruel when he first arrived at Giverny began to crystallize.

Meanwhile, Suzanne's health was failing. At the end of that 1895 summer Monet painted her in the garden, standing in the nasturtium-lined Grande Allée amongst late-flowering roses and dahlias, in a way that eerily echoed his previous paintings of Camille who, like Suzanne, never recovered from complications following the birth of her second child. It was not the first time Suzanne and Camille were portrayed similarly:

Monet's portraits of each of them as a woman in a white dress holding a parasol painted from contrebas are almost identical. The way the two women were linked in his art indicates that they were also connected in his mind and he must have been troubled by the way their fates mirrored each other, because after Suzanne's death he never painted anyone else again. Suzanne's inexorable decline made for an anxious and sombre household, and marked the end of Monet's long, fairly carefree peregrinations. Having such a large amalgamated family meant that whilst at home he was constantly interrupted by family matters, as there were always problems and sicknesses to worry Alice, and what worried her affected him and kept him there. This, together with the changeable weather, thwarted his painting, which he found very frustrating.

In February 1896 Monet wrote to the dealer Maurice Joyant thanking him for his letter regarding some woodblock prints of Hokusai flowers which he had in stock, but he added, 'You don't mention poppies and that's important because I already have iris, chrysanthemum, peonies and the volubilis.' Was Monet actively seeking to add to his collection of Japanese flower studies to help him with some decorative flower studies of his own? That summer he did not paint the pond: he painted by the sea in Pourville, while the newly planted water lilies were getting established. In November he was back in his autumnal garden: 'I am painting flowers which take up all my time.' These are

The third of Monet's paintings of his water garden to survive: The Bridge in Monet's Garden, *painted in the summer of 1895. Monet made the palette of yellow and blue, the same that he used in his sunflower-filled Vétheuil garden, even gayer by adding pink. From this painting we can see how small his first pond was. There are no water lilies yet.*

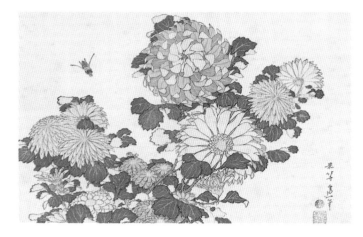

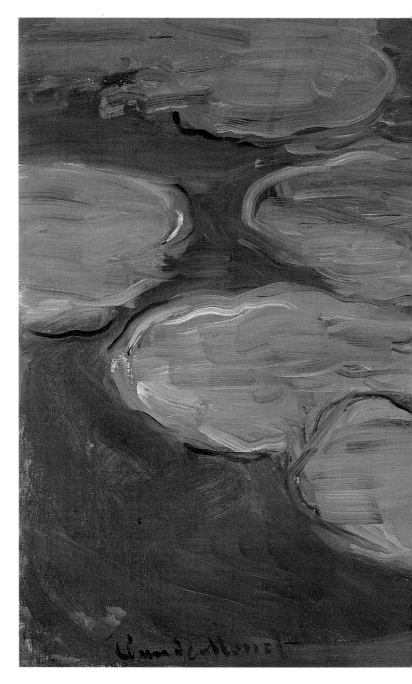

almost certainly the chrysanthemum paintings seen by the art critic Maurice Guillemot in Monet's studio the following summer. Monet's 'Chrysanthemums', rendered on a similar scale and similarly arranged to Hokusai's, closely resemble the close-up studies of water lilies that Monet began the following summer. The most detailed he would ever do, they were to be used as models for large-scale decorative paintings, for which he built a second studio.

The interview Monet gave Guillemot during the summer of 1897 'under the parasol beside his pond' is always cited because it establishes when Monet made his first steps towards his *Grandes Décorations*, initially conceived as a decorative ensemble for a dining-room. Guillemot described what he saw: 'Upon that immobile mirror float water lilies, aquatic plants, unique species with broad, spreading leaves and disquieting flowers of a strange exoticism . . . for these are the models for a decoration, for which he has already begun to paint studies, large panels, which he showed me afterward in his studio. Imagine a circular room in which the dado

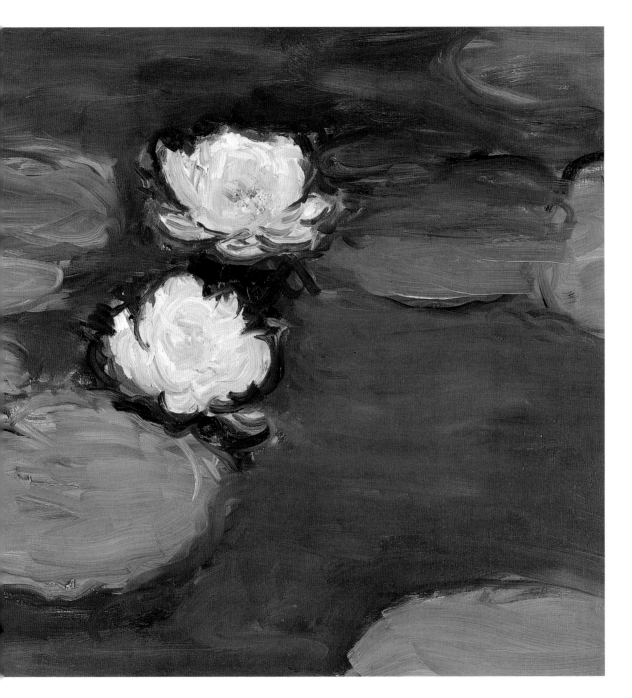

Water Lilies, *dated 1897-8: one of the early studies for Monet's Grandes Décorations cycle, influenced by one of his woodblock prints,* Chrysanthemums and Bee, *by Katsushika Hokusai. In November 1896 Monet had painted a mass of chrysanthemums from his garden in Hokusai's style, as Caillebotte had done with his orchids. By the following summer, he had replaced the chrysanthemums with the first of his water lilies as the subjects of a decorative ensemble, something entirely unprecedented. Latour-Marliac's success had sent many horticulturists scurrying to their hybridizing benches, but of all the Impressionists, only Monet was inspired to set up his easel by his garden pond.*

1889-1901 ❖ GENESIS OF THE WATER GARDEN

beneath the moulding is covered with paintings of water, dotted with these plants to the very horizon, walls of a transparency alternately green and mauve, the calm and silence of the still waters reflecting the opened blossoms. The tones are vague, deliciously nuanced, with a dreamlike delicacy.'

In the next eighteen months preceding the tragic conclusion of Suzanne's illness, Monet did no painting at all. Her death early in 1899 devastated the family. Helpless in the face of this loss, Monet sought sanctuary in the water garden, and at close, but not too close, proximity to his inconsolable wife, he painted his Japanese bridge series of 1899, giving nine out of the eleven paintings the title *Water-Lily Pond*. An idealized world emerges, as an enclosed, secure little paradise, limpid and serene, a complete contrast to the emotional desolation that filled the pink house at the top of the Grande Allée. For the first time, he painted the water garden with real feeling. Confronted by another senseless death, recalling buried grief, Monet sought solace in his garden, and these paintings were as beautiful as he could make them. He had done so before, after Camille's death, in Vétheuil, a golden vision under a brilliant blue sky, the most joyful and radiant garden he ever painted; and would do so again in the aftermath of Alice's death, with his sublime *Grandes Décorations*. As he looked into the 'mirror pond', took in his 'reflection bridge' of Japanese legend and contemplated the rafts of nymphaeas, was he reminded of his own lost nymphs, his two muses Camille and Sukey, who were now to be replaced by water nymphs, the nymphaeas who, endowed with eternal life, could be counted on to reawaken in the spring?

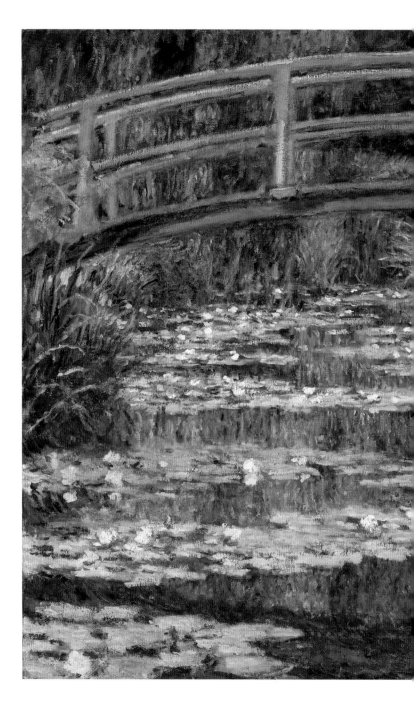

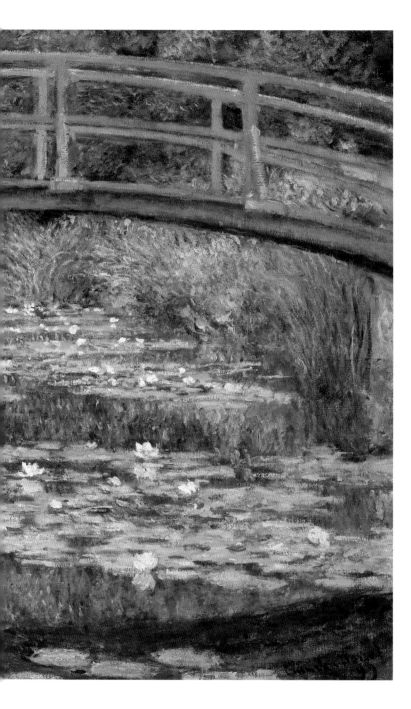

In the Japanese bridge series the flowery palette of his pond sparkles, the greens shimmer. He moves the Japanese bridge from side to side, but its arch is always the most imposing element in the picture. And then, towards the end, one painting announces the future. The bridge is hoisted to the top of the frame like a drawbridge and Monet's eye passes through to alight on the newly uncovered flowers on his pond. We move with him as he discovers this glory for the first time. It marks the moment he described many years later as 'the revelation of my pond'.

The death of Suzanne ended an era and closed the century. The new one opened with another Exposition Universelle in May 1900, to honour which the Grand and Petit Palais were built. Monet was there, with fourteen paintings on show, and the industrious Latour-Marliac too, with his treasured hybrids, in even greater variety. Afterwards Monet took the heartbroken and severely depressed Alice away from Giverny with him to London where he would begin his London series. The project of the decorated circular room was forgotten: the panel studies lay stored in the basement as dormant and as hidden as the water lilies submerged in the winter mud of his pond.

Only one painting in Monet's 1899 Japanese bridge series,
Water Lily Pond, *shows the bridge raised to the top of the frame, allowing a clear uninterrupted view of the flower-bedecked surface of the pond, which Monet presents as an enticing and glittering 'yellow brick road'. The popular 'down-the-road' motif was often used by Monet, but it acquires a special meaning in this context as the departure point of a journey.*
OVERLEAF *Early morning in late summer, the pond today as Monet would have seen it, in shades of acid green.*

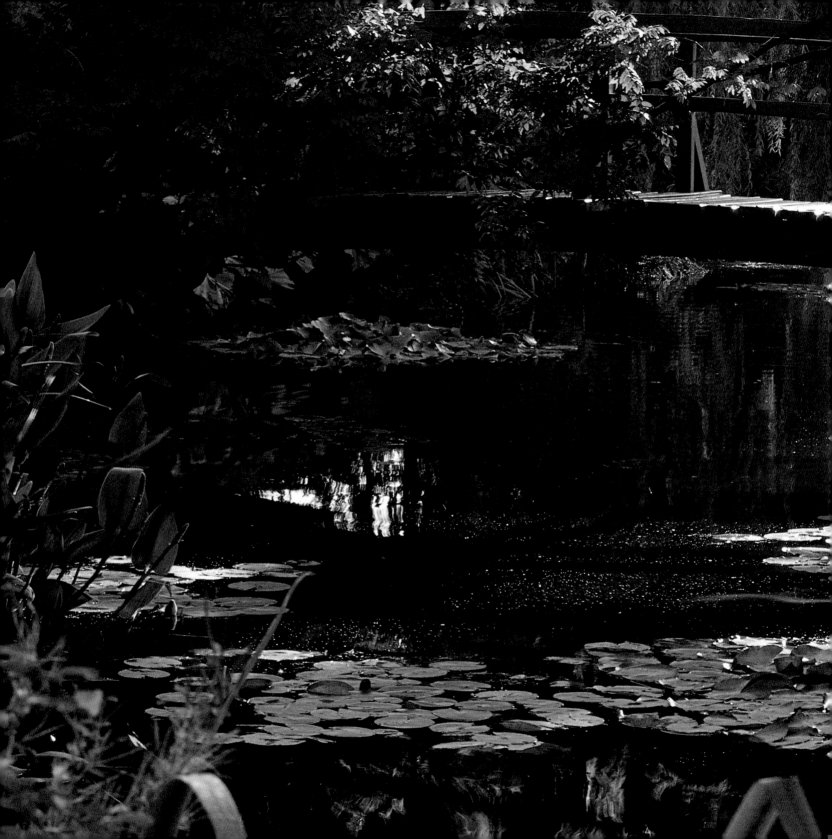

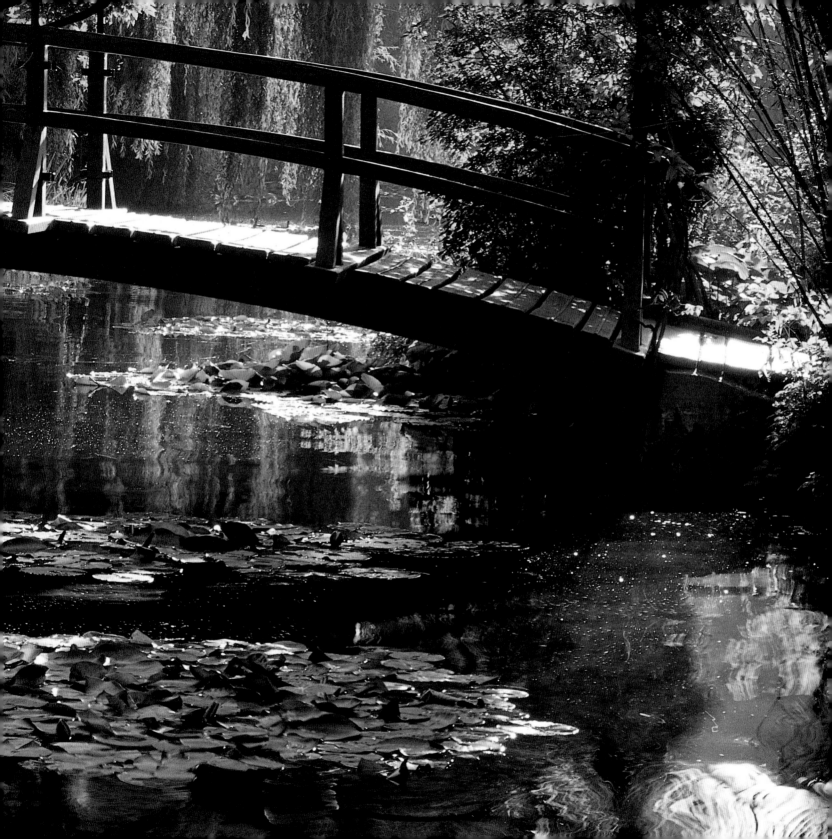

MIRROR OF NATURE

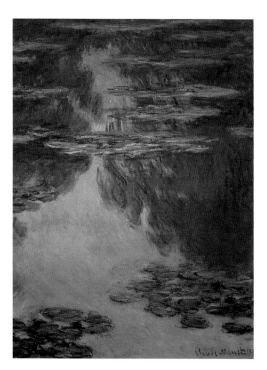

*'I have painted these water lilies many times, modifying my
viewpoint each time . . . since the water flowers are far from being the
whole scene; really they are just the accompaniment . . . The essence
of every motif is the mirror of water whose appearance alters at every
moment, thanks to the patches of sky which are reflected in it, and
which is its light and its movement.'*

Monet's 'mirror of water' (opposite), complete with its metallic sheen,
was the subject of his increasingly abstract 1907 series Water Lilies (above).

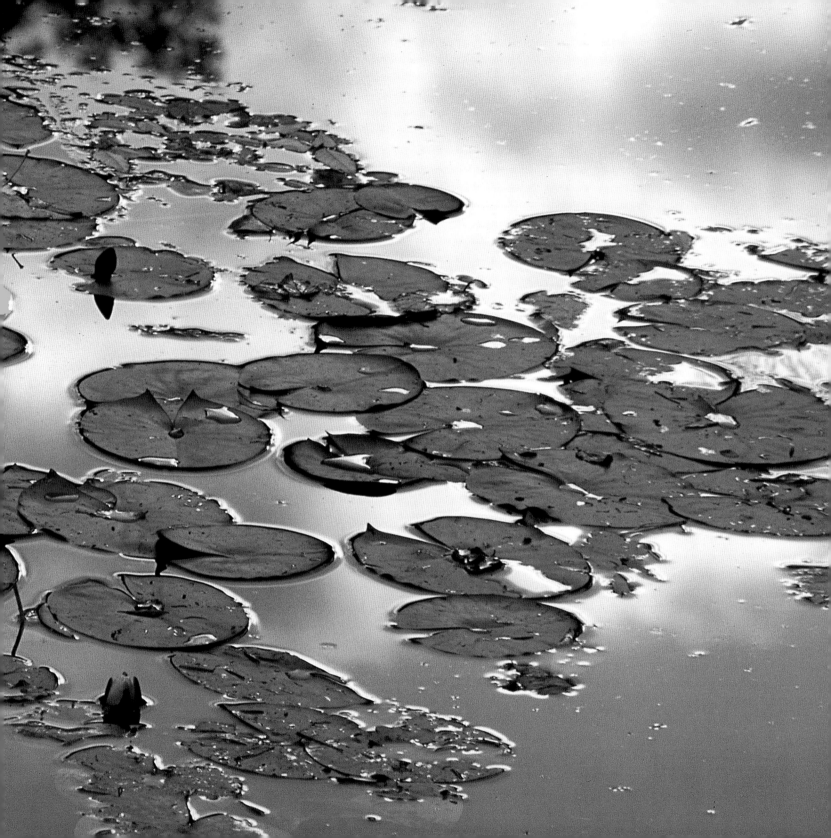

I HAVE ALWAYS LOVED SKY AND WATER, leaves and flowers. I found them in abundance in my little pool', wrote Monet, somewhat simplifying the scope of his pond, in which he recognized so many themes and motifs of his painting. Spread out over the surface, floating like clouds, as perfectly elliptical as his ice floes, was a bejewelled, mystical garden, arranged in a flotilla of rafts. But instead of seeing them right side up in the usual way, and instead of seeing them through an airy atmosphere, he now saw them through a distorting envelope of water. Even the sun and wind were making their usual mischief in a perpetual kaleidoscopic play of light upon the surface of the pond that in the blink of an eye could change from the clarity of glass to an impassable mirror. The merest breeze sent shivers across it, breaking up the reflection into shimmering particles of light. On still days, if you peered into the pond from the bridge you looked straight down on to its shallow, muddy bottom; but if you leaned slightly sideways this vanished and it became as deep and fathomless as an ocean in the way it mirrored infinite reaches of the sky. For the master visualist, it was the most fascinating of optical illusions, as elusive as a mirage, a bag of the most sophisticated tricks.

But this little pool, alive with visual possibilities, was too small for him. Only a single row of water lilies could be accommodated along what amounted to only a widened stream and by 1901 Monet had already exhausted the only angle from which to paint it. So on 10 May he purchased 30 acres (12 hectares) of meadow on the other side of the little Ru so that he could make a much larger pond. He was in such a hurry to have the land that the normally frugal Monet paid for it in full immediately.

The excavations took place during the winter of 1901, with Monet supervising. By February 1902, Alice was writing to her daughter Germaine, 'I really think that the works at the pond are getting on his nerves . . .' When Alice went to Brittany to minister to her ailing eldest son and unusually Monet was left at home, he wrote to Alice, 'I'm over my head with this pond . . . My presence is useful here with this persistent frost, despite splendid weather we can't plant anything at the pond, and although the works are progressing, it will take a long time, and I'm afraid I'm going to be in a real mess. And this aggravates me *un peu beaucoup*.' During the excavations the pond would have been dug deeper, and all the water lilies dug out and divided, so that they could be spread over a surface that now covered 65 by 197 feet (12 by 60 metres). Monet became increasingly frustrated because, as the winter proceeded, the ground remained frozen and the water lilies had to wait to be replanted.

Impatient to return to the pond, Monet probably instructed Félix Breuil not to divide certain lily clumps too drastically, so that he would not have to wait even longer for his pond to look fully embellished. He undoubtedly ordered many of Latour-Marliac's new hybrids – there were thirty-two varieties on offer by 1902 and they too needed time to mature. During the summer after the pond was enlarged, and the water lilies were recovering, Monet and Alice rented a chalet in Lavacourt, across the Seine from Vétheuil, from which he studied and experimented with all kinds of light effects upon the water. Monet returned to his sparsely covered pond during the summer of 1903 and for the next five years, until he went to Venice in 1908, he painted nothing else except a still life of a basket of eggs.

The garden around his enlarged pond was a decorative arrangement of winding paths surrounded by plants originating from Japan – rhododendrons, auratum lilies, irises and tree peonies, none of which excited Monet as much as its centrepiece of rafts of water lilies floating on a limpid mirror of light, clouds, trees and grasses. The water lilies embellished the pond as elegant spots of colour laid out on a floating palette. In his paintings the rafts were sometimes close together, sometimes wide apart, as his attention shifted from the anchoring rafts to a range of mysterious light harmonies from the delicate hues of aquamarine, turquoise, violet and mauve to the fieriest oranges and reds dependent on the whim of the sun. The whole was enclosed with irises, grasses, agapanthus and weeping willows hugging its banks. The bridge was now capped with a trellis and adorned with wisteria. This set piece had to be immaculately maintained for Monet to catch every nuance: the surface was kept as clear as glass and the sparkling luminosity of the paintings reflect this clarity. Every morning the gardeners performed its toilette, fastidiously clearing algae, scooping up willow leaves, rinsing off the lily pads, removing dead leaves and keeping the rafts trimmed to their perfect oval shape. Monet had the road outside the garden tarred to keep dust to a minimum.

Monet often painted through a curtain of foliage to create a secret, mysterious and private world. Here, the willow, bamboo and Japanese bridge add exoticism and the mirror of water provides a reflected dimension to the tableau which, with all the challenges it posed to the painter, was the one Monet was most interested in mastering.

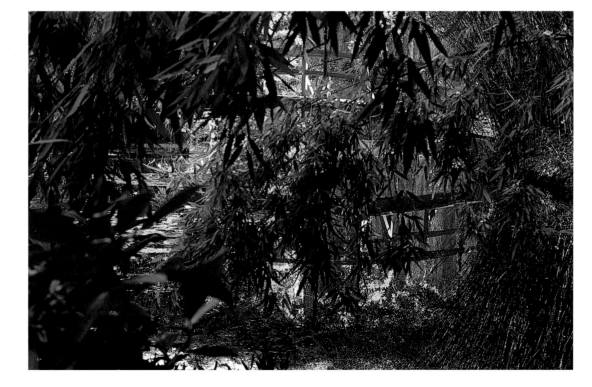

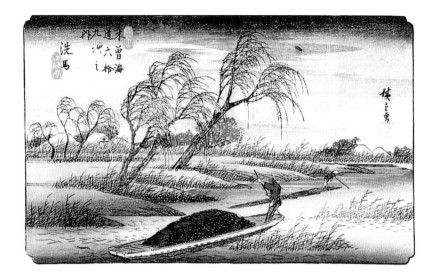

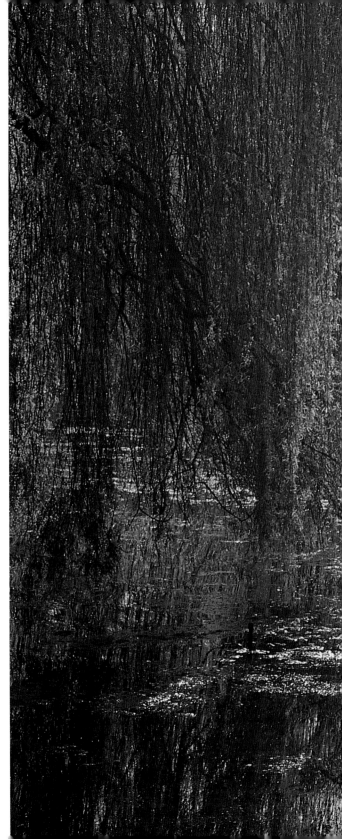

The timeless image of a man pushing his boat along reaches across continents and centuries. Even the shape and style of the boat seems universal. A woodblock print by Hiroshige, Full Moon at Seba, *1830 (above); willows, irises and wild water lilies also colonize the riverbanks of Japan, which has a climate and soil similar to northern Europe. The modern toilette of Monet's pond (right) is no different to the way it was looked after in his day (below).*

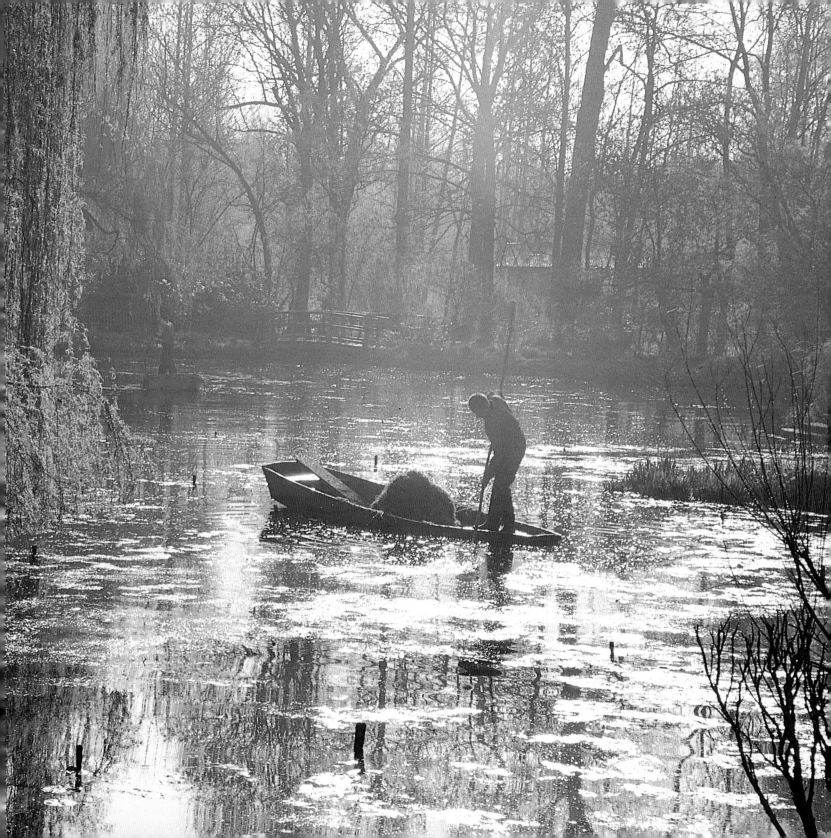

'I know very well that to really paint the sea one must observe it every day at every hour and from the same place', Monet had written from Belle Isle. This was the principle upon which all his art was based, coming as it did from pure observation, and since his pond was at the bottom of his garden, he spent more time looking at it than any other of his subjects. He went there at least three times a day, to study the light from different angles. Every detail was absorbed into his magnetic eye, that famously sensitive retinal screen Cézanne had so envied, the eye which Guillemot said 'observes, contemplates and stores away'. 'I became infatuated with light and reflection. And there you have it, the way in which I ruined my career,' he later recounted with a smile.

'Paint what you see, how you can', Monet counselled his step-daughter Blanche, who also painted; and he advised his friend and summertime neighbour, the American painter Lila Cabot Perry, to 'break down and

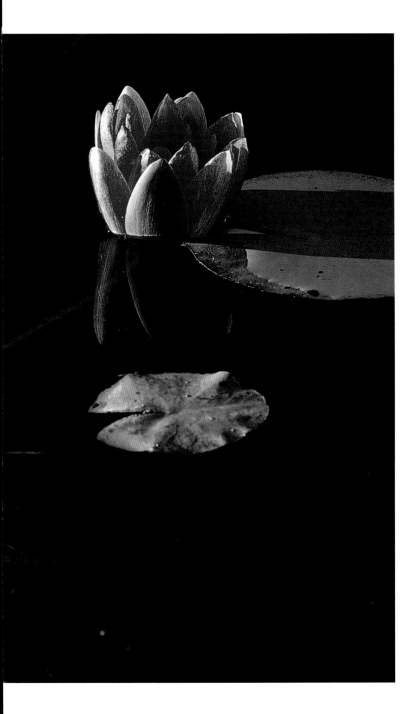

separate what you are trying to paint into particles of light and colour'. What he sought was a return to visual innocence, which he compared to what he imagined someone born blind would feel if the staggering wonder of nature were unveiled to him for the first time. Portraying the world reflected upside down is perhaps the closest Monet would get to this kind of unconscious purity, that moment before our brains scramble to sort out the confusion and reorganize the pieces of this unrecognized puzzle into a reassuring picture. Deconstructed sight was also an emotional experience he wanted to translate into painting, as he explained much later in a letter to Geffroy in 1912: he wanted 'to express what I feel before nature, and that most often, to arrive at rendering what I experience I totally forget the most elemental rules of painting, if they exist, every time . . .' His eye fell on every shadow, every permutation that the sun or clouds or a pearly grey sky created on the pond; and found imaginative and graceful ways of painting the irises and agapanthus, the willow and wisteria that were the foils to his real love affair with the light and the lilies. In his countless reinterpretations of the pond, he never repeated himself.

By the time Monet set up his easel again beside his small paradise, his head was so full of stored-up ideas

Monet took this picture of his hat reflected in the pond (far left) as a joke. Although the Monet-Hoschedé children enjoyed photography, Monet had no use for a camera. His eye was a thousand times more sensitive, and he interpreted what he saw rather than merely recording it. Nymphaea 'Marliacea Ignea' (1893) (left), emerging from the clear water, is an early hybrid and the obvious model for the red water lilies of his early paintings.

that by the end of 1903 he had presented his entire repertoire of experiments in composition. The rest of his life was devoted to explorations of combinations of light and colour within these forms. His paintings became as detailed and luminous studies of light on the surface of water as those on the stone façade of Rouen Cathedral. His most radical departure from conventional painting was to lose the bank – the horizon – and so to lose perspective: only the water-lily rafts acting as situating anchors identify the pictures as being of a pond. He was moving into the abstract and was so ahead of his time that it was 1978 before someone realized that one of his water-lily paintings in the Musée Marmottan was hanging upside down.

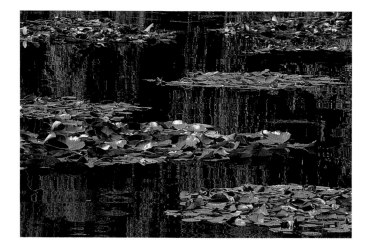

He also wanted to render a different kind of 'time'. The 'master of the glimpse' was now looking beyond the glance, the glory of the moment, to something deeper and more sustained. Odes to the beauty of light, his paintings shifted their emphasis from jaunty snapshots of bright, breezy afternoons, of white clouds rolling across a blue sky, to serial studies of light of a more sophisticated and meditative nature, synthetized into the absolute. Monet's pond became a most mysterious place. He sought its brooding character in the moody half-light of dawn, twilight and dusk to find sober harmonies he had been working towards for a long time. Ten years earlier he had written to Geffroy: 'I'm still struggling as well as I can with the admirable landscape motif, which I've had to do in every weather in order to make just one which would be of no weather, of no season . . .', adding later, 'above all the envelope, the same light spreading everywhere.' This would explain why he destroyed a whole series in which the season, weather and time of day are easily identified by the blue sky, perky white clouds reflected in water and grassy foliage on its banks. Only one survives, referred to as the Sutton picture, sold to the dealer Mr Sutton early on. Monet regretted the painting's continued existence and tried unsuccessfully for years to buy it back so that he could destroy it.

A flotilla of water-lily rafts (above) seem to drift desultorily across Monet's luminous pond but they are firmly anchored in baskets. The pond looks similar to Monet's 1904 Water Lilies *series (right), in which the bank makes one of its last appearances. Reflected light and Monet's creative licence make it impossible even for experts to identify the water lilies in his paintings.*

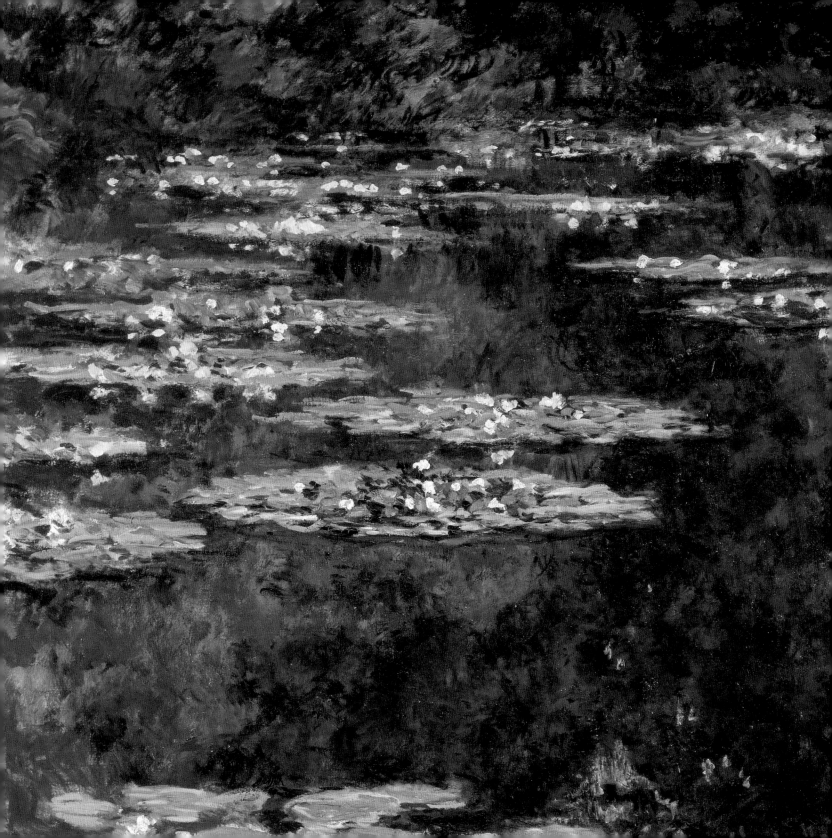

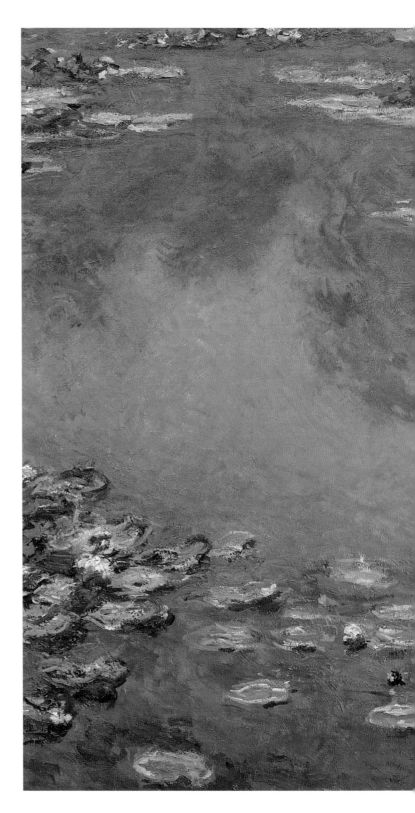

Looking at the dreamy tonalities of Monet's paintings of the summer of 1906, you would never guess the agonies he was going through. These were charted by Alice in letters to her daughter, Germaine, which are fascinating for what they reveal about the highly strung Monet's relationship with his work and how difficult it must have been for his family to live with a man whose moods were ruled by the weather. If Monet had been under the illusion that digging a small pond in his garden would provide a protected and climatically stable environment for his experiments and explorations with light, he was deluding himself. He was entirely at the mercy of the light and low pressure, and, fickle to the core, they played havoc with his plans and emotions.

Alice to Germaine

20 February 1906: 'Monet is starting plantations of large bamboos around the pond, and he does not leave it';

25 February: '. . . he is only waiting for the first green shoots to appear at the pond so as to start painting';

27 March: 'Monet is disconsolate, his dearly cherished bamboo plantations are jeopardized [by hot days, cold nights and frost] . . .';

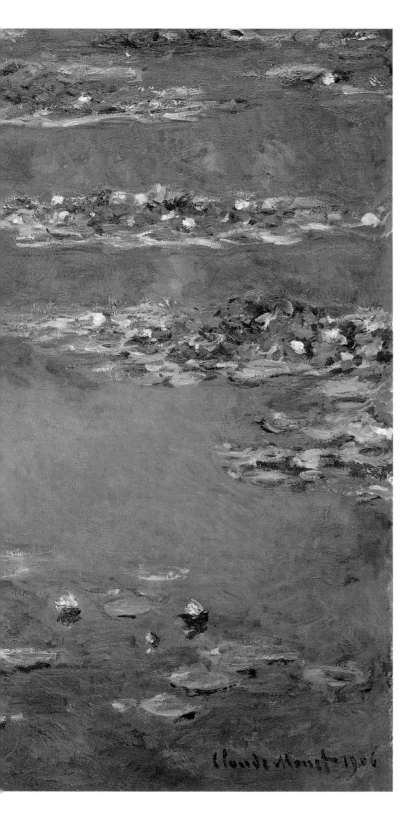

18 May: 'Monet's studio is "a regular dog-hole"';
29 May: '...he keeps saying "one cannot be and have been" and that he can no longer do anything good ... There are now a few water lilies in the pond ...';
4 June: 'Monet is most desperate, for the violent wind, I should rather say the storm, is breaking all the flowers and prevents him from working; he is most upset (and bad tempered)';
23 June: 'The weather is too unstable for poor Monet who loses heart as the days go by, and is unable to produce anything good ... The water lilies, which are superb now, are never the same from one moment to another; they perpetually change under the wind ...';
26 June: 'Monet is in low spirits for the weather is so bad! This perpetual wind prevents him from working, and it is such a pity! For July is drawing near ...';
7 July: 'The poor water lilies look so sad. Half of them at least have died; a completely wasted summer ...';
13 July: 'The sun has been shining for three days ... Monet went back to work but his heart is not in it. The water lilies have suffered from cold, and there are very few left. He cannot find his effects any more ...';
31 July: 'The weather is unstable and poor Monet is gnawing his heart out, for it will soon be the close of the season for the water lilies; in August they usually get smaller ...';
12 August: 'Monet is working like a madman and much too much ...'

Turquoise blue sky reflected in the water and the green harmonies of the leaves of Nymphaea *'Escarboucle' (1909) (far left) show the kind of light effects upon which Monet modelled his 1906-7 Water Lilies painting (left), a couple of years before the hybrid was developed.*

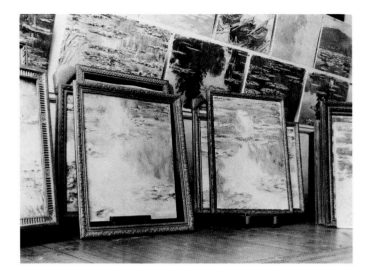

Monet had promised Paul Durand-Ruel an exhibition of this second water-lily series for May 1907, but achieving his ever more ambitious visions was a formidable task, even when the weather was stable. 'I am working but with great difficulty despite the good weather because I am finding it harder and harder to satisfy myself, and this breaks my heart at times.' In April 1907 Monet cancelled the exhibition after destroying some thirty canvases. After five years of work, he had, he said, only five or six paintings that were 'passable'. He reported dizzy spells and blurred sight, which Alice interpreted as psychosomatic symptoms caused by anxiety about the exhibition. He was advised to turn his paintings to the wall and take a vacation, so at the end of the summer of 1908 he went with Alice to Venice for ten weeks, returning to his water-lily paintings 'with new eyes' and putting the final touches to them. 'Do not title this series as "The Reflections" but as "The Water Lilies series of landscapes of water" ', wrote Monet to Durand-Ruel, 'and in the catalogue let them appear as a list of numbers with the year in which each was painted as it is not possible to identify them in any other way.' Forty-eight water-lily paintings featured in the exhibition, which opened in May 1909. Marcel Proust went, with Bizet's widow, and used them in his description of a fictitious water garden by the River Vivonne in his book *Swann's Way*. The show was a sensation: *le tout* Paris was bowled over. Monet's work as always elicited contradictory opinions from fellow artists and critics, but he was overwhelmed by letters of congratulation and offers to exhibit abroad.

Six years were to pass before Monet resumed painting his water lilies, the most difficult of his life. The year 1910 started badly, with the Seine bursting its banks, flooding Giverny for many weeks. The Japanese bridge was nearly submerged as the water made its way up the garden to the middle of the Grande Allée. Monet could think only 'of my poor flowers sullied by mud', and his pond, his window to the world, shattered. The 'terrible Félix' as Alice called him – a humourless man, '*droit et sec* [straight and dry]' – did nothing to soothe the pessimism-prone Monet. The flood finally abated in March, and as it ebbed from the garden, leaving a terrible stench of slime, Alice was diagnosed with leukaemia. Treated with radiotherapy X-rays, she had

Monet's studio, photographed by his dealer Paul Durand-Ruel in 1908, showing some of the water-lily paintings he had been hoping to show in the exhibition planned for 1907 but postponed for two years by Monet.

a remission but on 19 May 1911 she died. 'My adored companion is dead ... I am wiped out', wrote Monet to his friends. 'I am crippled.'

Monet, who had painted a few local scenes during her illness, did virtually no painting for three years, only picking up his brushes to complete his Venetian pictures for an exhibition in 1912. 'Age and grief have exhausted me', he wrote a week before the anniversary of her death. A couple of months later, his son Jean, who had suffered a kind of neurasthenia for many years and a mental breakdown, was diagnosed with a cerebral congestion which would result in loss of reason. Monet attempted to work, and painted his house and front garden. Two weeks later he realized he could not see anything with his right eye. On 26 July he was diagnosed with cataracts in both eyes but refused to be operated on. 'The operation is nothing,' he wrote, 'but afterwards my sight will be totally changed, and this is crucial for me ... As a final blow, a frightful cyclone made havoc in my garden. My weeping willows of which I was so proud, ravaged, with branches torn off, the most beautiful one entirely broken ... a real grief for me.'

He was still very depressed in December. 'As for me,' he wrote to Geffroy, 'I am neither better nor worse as

regards my sight and my morale. It's certainly the latter which is the sicker. However, we are having some beautiful days which revive me a bit.' It was not to last. 'I had always wanted to think that I would arrive progressively to satisfy myself and in the end, achieve some-thing that was good,' he wrote to Durand-Ruel in January 1913. 'Hélas! I shall have to abandon this hope, as I no longer feel anything.' His friends knew that, given time, his desire to paint would return: it was his lifeblood, stronger than anything.

A month after this sad letter, Monet's son Michel and Suzanne's two children prised him away from Giverny and they all went for a jaunt around Switzerland in Monet's new closed and heated motor car. He was enchanted by the fairy-tale snow that sparkled in the sunshine and his senses reawakened his passion for beauty. He sent many postcards: 'I am well, and above all, filled with wonder.' 'I am absolutely filled with wonder it's so beautiful.' When he came back in March he was 'so happy and in fine fettle from our little trip in Switzerland.' The alpine air blew away the cobwebs in which he had been caught so long, inert. 'I have seen such beautiful things that at last, I seem reborn ... I almost feel disposed to attempting to paint again.'

The last photograph of Alice Monet, taken in July 1910, which Monet kept on his desk. Beside her is her granddaughter, Suzanne's daughter Alice Butler.

❖ 1913-26 ❖

THROUGH THE
LOOKING GLASS

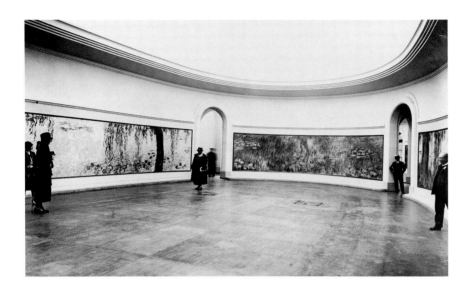

'There is nothing else before us but still and silent water,
flowers that open and close, shivering light, the cloud
that passes – nature and her mystery . . .'

Gustave Geffroy

One of the elliptical rooms in the Orangerie (above), photographed c.1930.
Monet insisted that the Grandes Décorations be glued to the walls, remain
unvarnished and be lit as naturally as possible. Detail (right) from the first of
the four panels of Morning (see pages 80-81) in the first room.

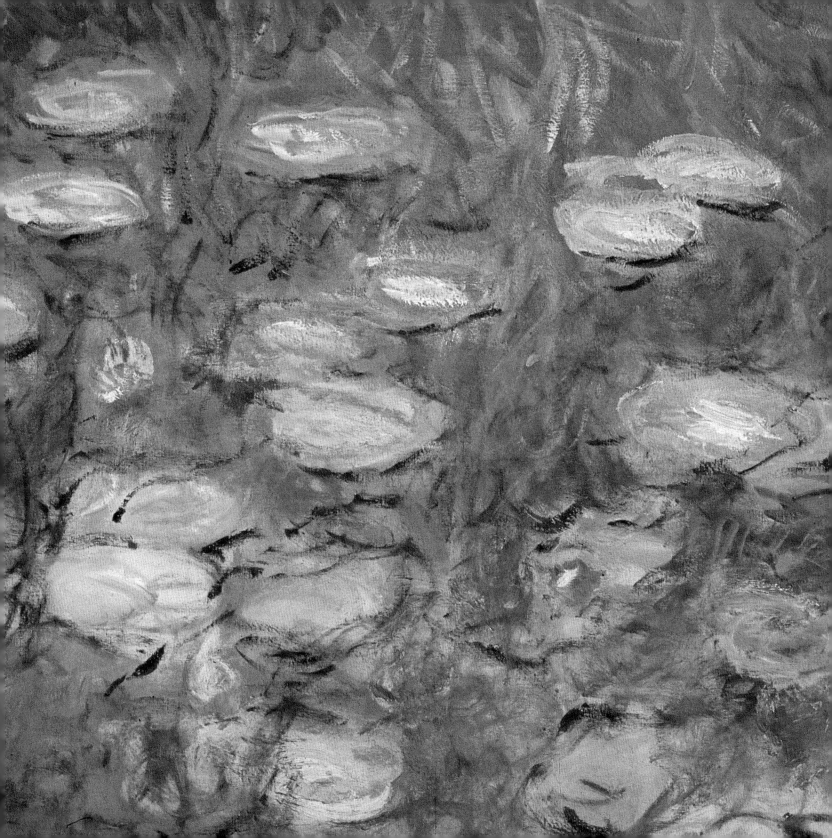

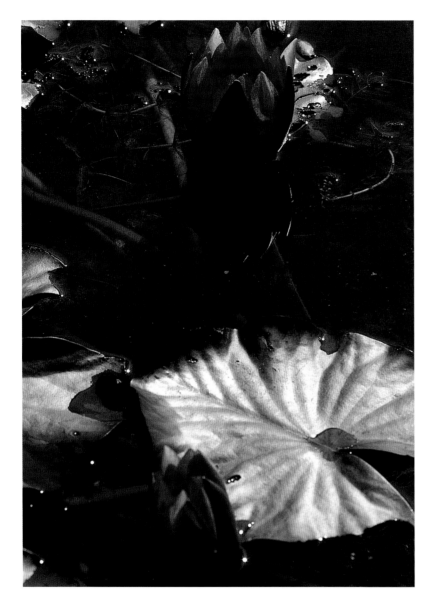

Nymphaea 'Sirius' (1915). In a fictional account of a garden inspired by Monet, Proust speaks of water lilies 'glowing, towards evening . . . with the roseate dreaminess of the setting sun . . .'.

THE LIFE OF THE WATER LILY unfolds in a perpetual cycle of resurrection and renewal. Each spring, rising from the pond's murky bed, the tendrils push their way to the surface where they throw out leaves and flowers. Every evening the petals fold up and the tendrils pull the closed bud underwater where it lies submerged until the following morning, when it re-emerges and re-opens. The water lily generally flowers for three to four days before making its final descent for the seeds to ripen in the pod. Encased in a gelatinous substance, the seeds are released three weeks later. They float to the surface and are carried along by the current before drifting back down to settle in the mud to regenerate.

It was ever thus. The Egyptians pounded the seeds and tubers of water lilies, rich in sugar and starch, into dough and baked it. Cultivating their 'bread' was as easy as following the exhortation 'Cast your bread upon the waters': they rolled the seeds into balls of mud and threw them into the River Nile, where they drifted down to the bottom and lay dormant until the spring floods kickstarted them into life.

And so it was for Monet. Another death in the family brought resurrection in the spring. This time it was his son Jean who collapsed in Monet's studio in February and died there a few days later. By all accounts, this was as much a mercy as a tragedy. Monet had bought Jean and his step-daughter Blanche, who had married Jean, a house

in Giverny, and Blanche had been nursing both her husband and father-in-law. Following Jean's death it was decided that Blanche would move back into her childhood home for good, and look after Monet. The widow and the widower comforted each other. A devoted and loyal companion, Blanche ran the house and, being a painter herself, she provided Monet with both the domestic stability and the genuine interest in his work that Alice had given him, indispensable in the solitary business of painting.

Perhaps in preparation for Blanche's return, Monet decided to have a spring clean and repaint his house. Tidying his studio and sorting out his paintings took him to the basement, where he stored his canvases, and poking around there he came across the big close-up studies of the water lilies that he had been going to use as models for his 'old dream' of the large decorative ensemble he had been planning and discussing with Maurice Guillemot seventeen years before.

For Monet this discovery shone like a beacon at the end of his long, dark tunnel. He fished the canvases out and brought them up to his studio. The prospect of renewing this enormous 'project that I had, a long time ago now: of water, water lilies, plants but on a very large surface' was exciting; but it was also daunting. He felt that at the age of seventy-four he was really too old to undertake such a task on so vast a scale – something he had not attempted since the enormous seminal canvases of his youth, *Femmes au Jardin* and *Déjeuner sur l'Herbe*, for which he had to dig a trench in order to reach the top to paint it. But his friend and fellow garden enthusiast, the statesman Georges Clemenceau, to whom he had become close in recent years and who

knew how much he needed to lose himself in work, persuaded him to proceed with the incitation 'stop procrastinating . . . you can still do it, so do it'. And so began the *'travail gigantesque, longuement medité, lentement executé* [the enormous work, long in the planning, slow in the execution]'.

Every hiatus in Monet's painting had been followed by feverish and prolonged periods of work. True to form, on 30 April he wrote to Geffroy, 'As for me I'm feeling marvellous and am obsessed by the desire to paint . . . I even intend to undertake some big things, for which you will see some old attempts which I found again in a basement. Clemenceau saw them and was amazed.' He set up his easel again by the pond, with huge canvases anchored by ropes wrapped around stakes or stones. Monet knew he would have to have a larger studio built to accommodate the enormous panels but waited, he told one critic, 'until the idea of the *Grandes Décorations* had taken shape, and the arrangement and composition of the motifs had gradually inscribed themselves on my mind'. In June, he wrote: 'I've gone back to work . . . up at four in the morning, I struggle all day and by evening I am exhausted. My sight is fine again . . . Thanks to work, the great consoler, all is well.' In July, Geffroy was invited to see 'this really big thing' Monet had begun.

But on 3 August, Germany declared war on France and the village of Giverny emptied. 'Many of my family have left . . . a mad panic has possessed all this area. If it were ordered or dangerous, I would make Blanche understand that she must go,' Monet wrote to Jean-Pierre Hoschedé's wife, 'but I would remain – too many memories retain me – where half my life has passed,

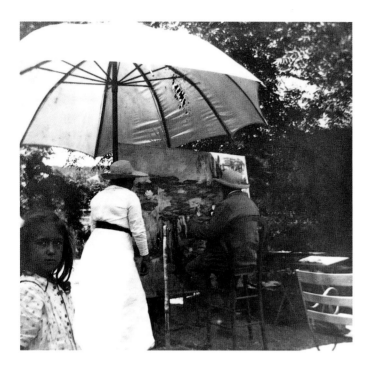

'Only occasionally in ordinary life do we catch glimpses of the world as pure appearance, in which identities are, as it were, loosened from their moorings and floating free - as perhaps when we are just rising out of sleep and the room around us drifts into view like a flotilla of nameless patches of colour ... Such states are unbidden. We find ourselves in them. But when an artist moves into this state, he does so at will, through disciplined practice with nothing dreamy about it.'

Andrew Forge

and *en somme*, I prefer to die here in the midst of my work rather than save myself and leave everything that has been my work to thieves and enemies.' By October the village was full again – of the wounded. A makeshift hospital was set up in an American sculptor's house in the village, for which Monet undertook to supply all the vegetables. He resumed painting on 1 December 1914: 'I've begun working again; it's still the best way of not thinking of present sorrows, although I'm rather ashamed of thinking about little researches into forms and colours while many suffer and die for us.'

He worked furiously, as if haunted. The huge panels soon overwhelmed the second studio, and in July 1915 he obtained permission for a third studio to be built on the site of an old chicken coop. It was completed by

Jean-Pierre Hoschedé took this picture (left) of Monet with the ever attentive Blanche, hovering beside him, on 8 July 1915, a week before permission was granted for the building of the third studio. On his easel is a painting (right) called, like countless others, Water Lilies. After a long absence from painting following Alice's death, Monet was feeling his way back into painting his pond and here he introduced reflected willows into his compositions, which recently had featured only water-lily rafts. Such manageable-sized canvases were used as 'swatches' for the huge panels of the Grandes Décorations which could not be accommodated across the path.

OVERLEAF *The lime-green curtain of weeping willow is a marvellous foil for cloud-like water-lily rafts.*

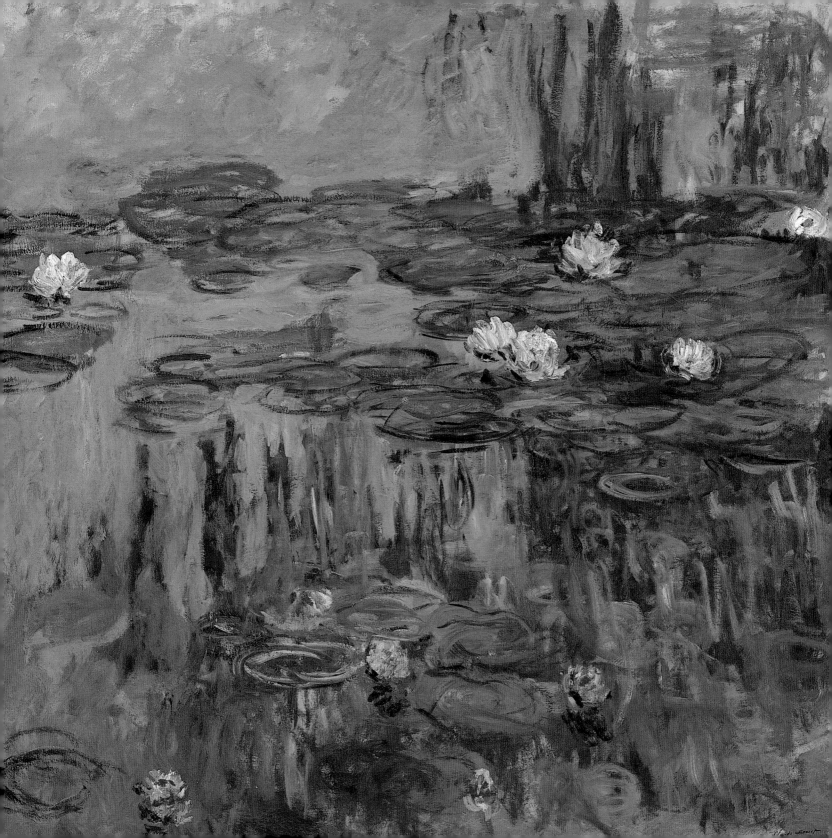

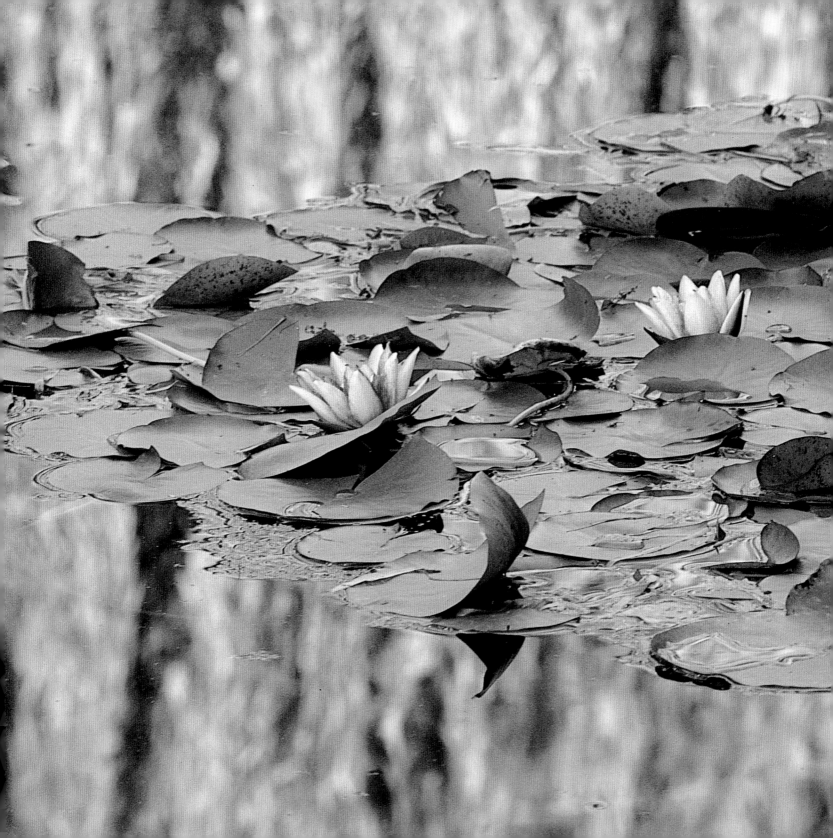

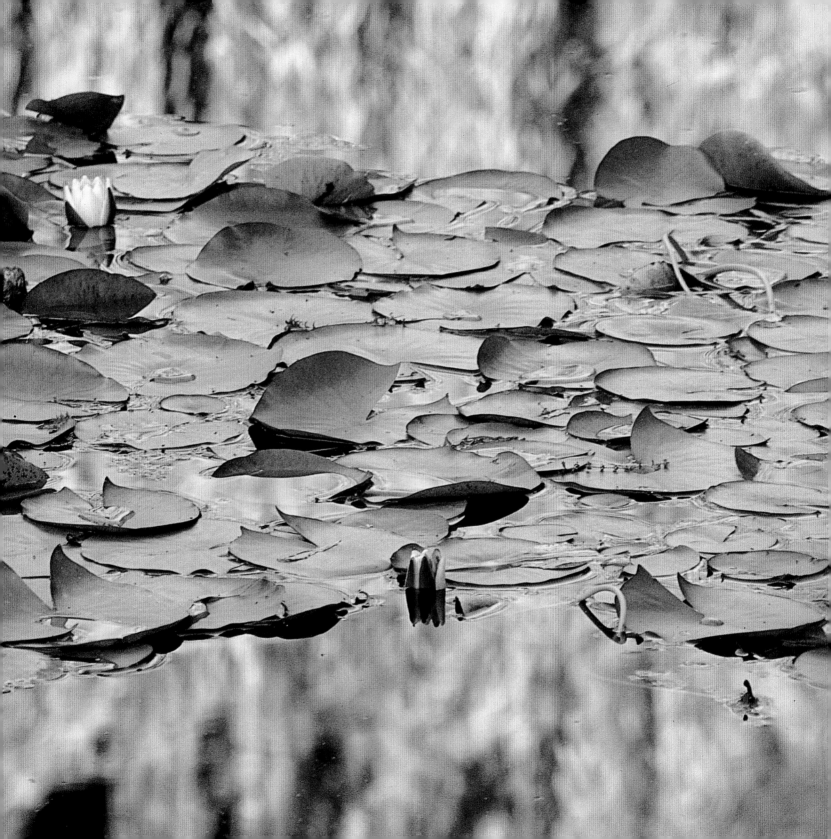

September, precious manpower and materials having been put at his disposal by the Prime Minister Clemenceau, who also gave Monet special dispensation for using train space for his canvases, paints and chassis, knowing the project, when complete, would become one of France's most precious national treasures.

'What he desired first and foremost', wrote Jean-Pierre Hoschedé in his memoir of Monet, 'was a total spread of light in his studio coming from the sky, and to achieve this the roof was entirely made of glass.' In the new third studio Monet was trying to create the perfect conditions for painting, which had eluded him all his life. It became a halfway house between *plein air* painting and studio painting, appropriate for his old age.

Monet, who had always defended Giverny from any municipal project that might deface it, found his studio very ugly and was ashamed to have betrayed Giverny in this way. It was enormous: 72 feet (22 metres) long and (40 feet) 12 metres wide. Vellum blinds protected the paintings from the sun, and it was aerated by electric ventilators, subsequently stolen during the Occupation.

The canvases of the panels were all 4 feet (1.2 metres) in height, so that they could be joined together, but varied in length from 6½ to 8 feet (2 to 2½ metres). To paint the upper part of his canvases, Monet stood on a table. Charles Stuckey has raised the question as to how he painted the bottom part, which is still a mystery, but

perhaps grown diminutive with time he just bent over. These murals, too enormous to move outside, were painted from studies he did outdoors as *aides memoires*, but the pond was now so deeply internalized that observation had fused with memory. He was not even painting what he was seeing with his eyes, which for most of the time, he said, were 'playing tricks' on him.

Although glad to be using such big brushes because larger strokes made painting easier for him, Monet worried about the quantity of paint he needed, the amount he was using and how much it and his materials were costing. Durand-Ruel had paid him a sizeable advance at the beginning of the war, but obviously the future was as uncertain as the present.

The canvases were stretched and fixed to a wheeled chassis to make them easy to move. He could guide them around, placing and arranging them how he liked, and he and Blanche became adept at trundling them about. Since they were all the same height he could create a completely enclosed continuous aquatic environment that was almost womblike. Agatha Rouart Valery, who visited Giverny as a young girl, described how Blanche, who was even smaller than Monet, would 'tackle the weighty easels and close them around us ... From one visit to the next their number and diversity intrigued us more and more.' Their form and composition were influenced by Japanese screen painting – in their panoramic format,

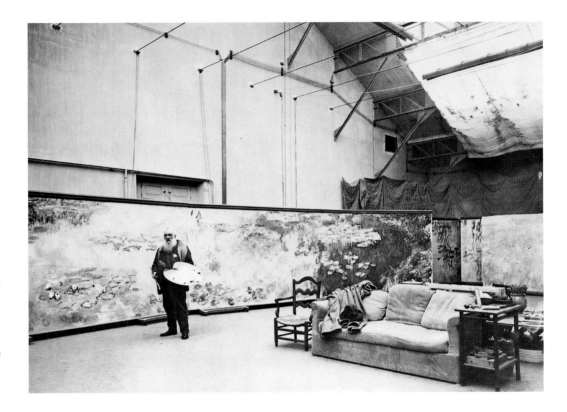

Monet inside his third studio (left), which was built to house the enormous panels that would all but bring the pond inside. In a visual reversal (right), the third studio became part of the all-seeing, all-absorbing eye of the pond.

the seasonal and temporal progression, the vibrant colours and in the arrangement of their foreground and background motifs within the picture.

The art dealer René Gimpel has given us an evocative account of the moment when Monet took him into the third studio, 'built', Gimpel said, 'like a village church.' 'Inside, it is only a huge room with glassed ceiling, and there we found ourselves before a strange artistic spectacle: a dozen canvases stood on the ground, in a circle, all next to each other, all approximately two metres in length and a metre 20 high; a panorama made of water and water lilies, of light and sky. In this infinity, water and sky have no beginning or end. We seemed to be witnessing one of the first hours of the birth of the world. It is mysterious, poetic, deliciously unreal; the sensation is strange; it is uncomfortable and pleasurable to find oneself surrounded by water on all sides without it touching you.'

Time and again Monet wrote of shutting himself up 'with work, in order not to think any more of the horrors being endlessly committed', of losing himself in his painting so he would not have to think too much about 'this terrible, frightful war', but of course he was thinking about it all the time. He could hear the gunfire coming from Amiens; he could see war all around him, every time he crossed the road to his pond – the soldiers, the

stretchers, the convoys. 'I don't see anyone', he wrote, 'only the poor wounded. They are everywhere.' Every evening he and Blanche read in the newspapers of so many deaths and the new weapon, gas, that was blinding thousands of soldiers.

What was going on outside Monet's world was in a sense also going on inside it. The size of his panels seemed to echo the scale of the tragedy. In his race against time and light he was facing his old challenges. But the speed with which he painted was deployed now not, as of old, to seize the moment but to prolong the moment in the face of his own mortality and the deaths of the last of his oldest friends – Degas, Mirbeau, Renoir – and the fate of the soldiers who died in their thousands every day. In his stubborn refusal to be operated on for his cataracts, he too was constantly confronting the onset of his own blindness, as the soldiers faced the possibility of theirs.

As the war progressed Monet's sense of the triviality of his art compared to the reality of war was replaced by a feeling of comradeship with the soldiers, that he too was engaged in battle. A journalist quoted him, explaining that 'to work was again to defend France and to defend his own life at the same time'. This sense of participation in the war and the urgency he felt account for his demands that transport for his canvases be given clearance and priority on the trains: 'I speak as if I have a lot of time, which is pure folly as it is to have undertaken such a task at my age.' As in the past, the greater the tragedy, the more loving his art. In the face of a godless and godforsaken world, he had to redress the balance, to preserve his dream of the beautiful world he had always sought to find and

1913-26

78

communicate. He conducted a noble struggle to reaffirm the healing power of beauty. But in the face of terrible destruction, it was not always easy to believe in it.

Monet's water garden became his Garden of Gethsemane, in which he was plagued with doubt and a sense of futility. By 1917 a million of his countrymen were dead. 'I no longer have the courage for anything, saddened by this appalling war first of all, by my anxiety for my poor [son] Michel who risks his life at every moment . . . as a consequence, I'm disgusted by what I'm doing, and I will never come to the end of it.' At the same time he was compelled to keep painting. 'It is literally true that the painter was so dominated by his task that he was unable to stop . . . He told us that at certain of the most intense periods of his work, through the night in dreams, he continued to spread colours on the canvases, descending lower, ever lower . . .' wrote Arsène Alexandre.

During the darkest hour of the war, at the height of the German offensive in 1918, the battle was only 37 miles (60 kilometres) away. Suddenly Monet no longer felt ashamed of painting, saying he wanted to 'put it all down'. He reiterated his wish 'to perish here amidst what I've done'. The Allies launched their counter-offensive. 'Dear and great friend,' he wrote to Clemenceau, 'I am on the eve of finishing two decorative panels which I wish to sign on the day of Victory, and am asking you to offer them to the State . . . it's not much, but it's the only way I have of taking part in the victory.' His seventy-ninth year began with a visit by the great Clemenceau: '. . . it was his first free day, and he came to see me.'

Detail from the second panel of Morning.

THROUGH THE LOOKING GLASS

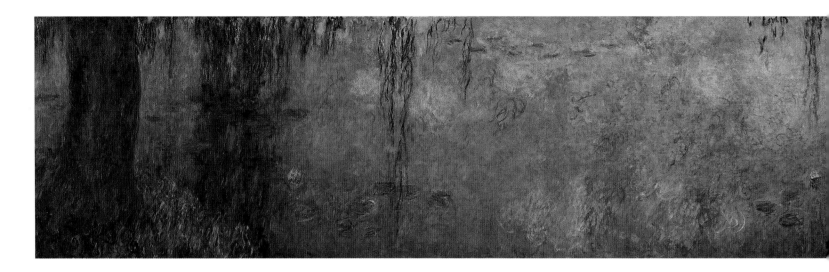

'Weeping willows on the shores will at intervals lift their strong rough trunks and let
their hair droop in long disconsolate threads – and one will marvel at the spectacle of this luminous
enchantment, characterized by dark blue, pink and white, and green and gold harmonies.'

François Thiebault-Sisson

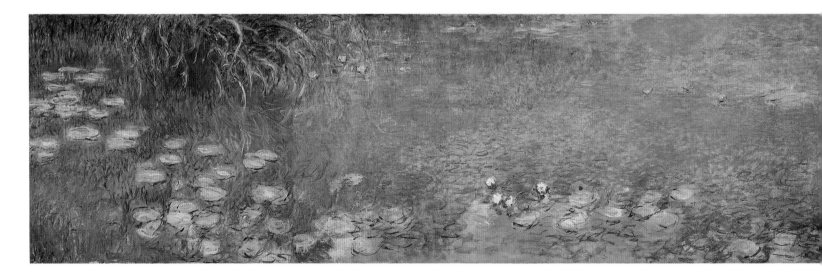

1913-26 ❖ THROUGH THE LOOKING GLASS

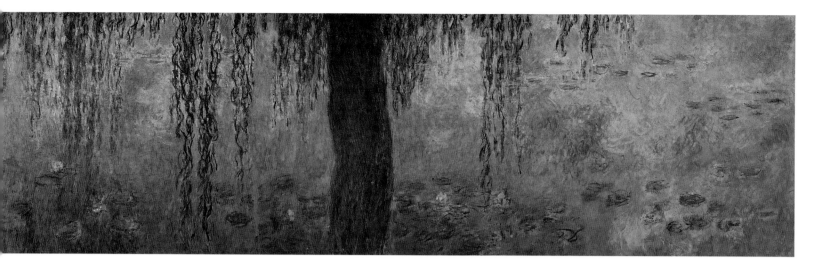

ABOVE *Triptych called* Morning with Willows *in the second room of the Orangerie.
In the tradition of Japanese screen painting, trunks of weeping willows figure prominently
on either side of the 'screen', leaving empty space and a sense of distance in the middle.*
OVERLEAF *Detail from the third panel of* Morning with Willows.
BELOW *Four panels make up* Morning *in the first room.*

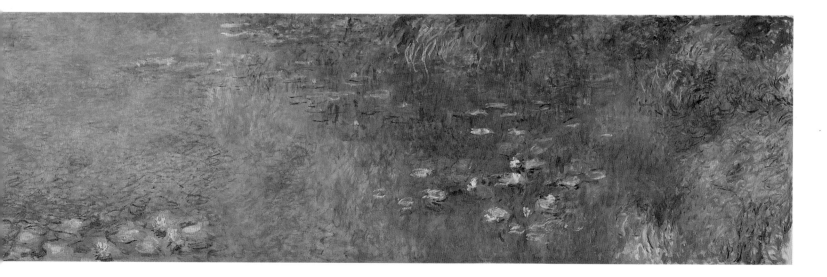

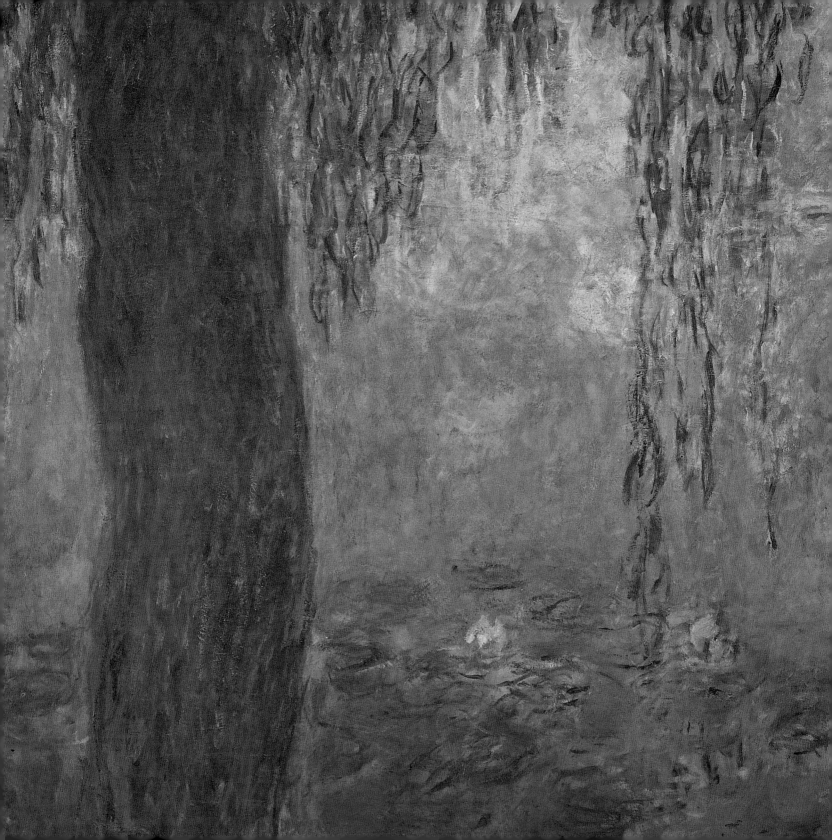

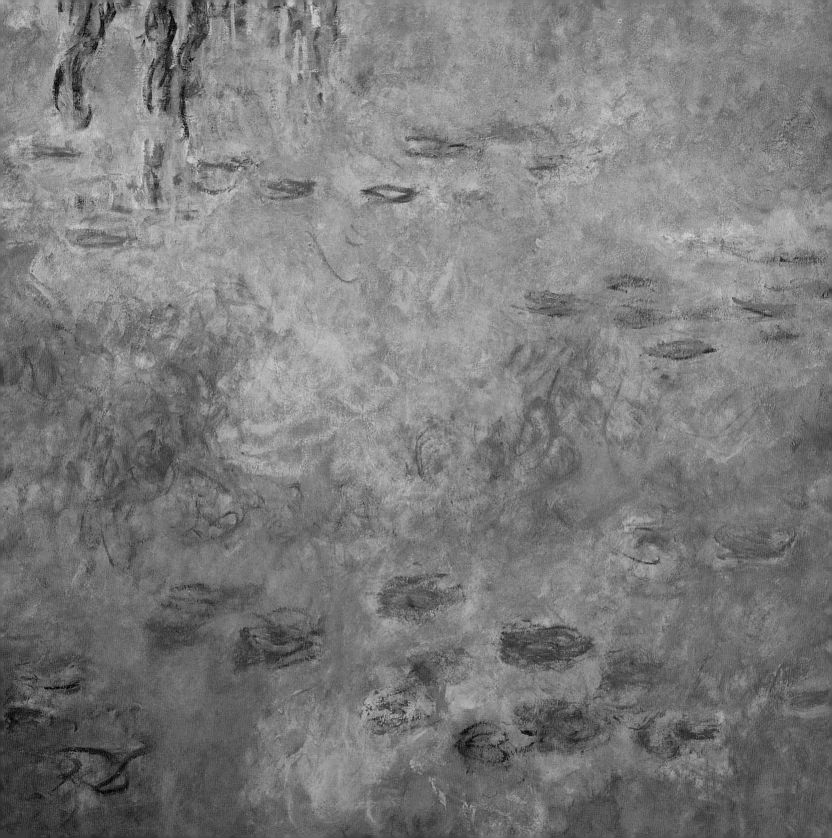

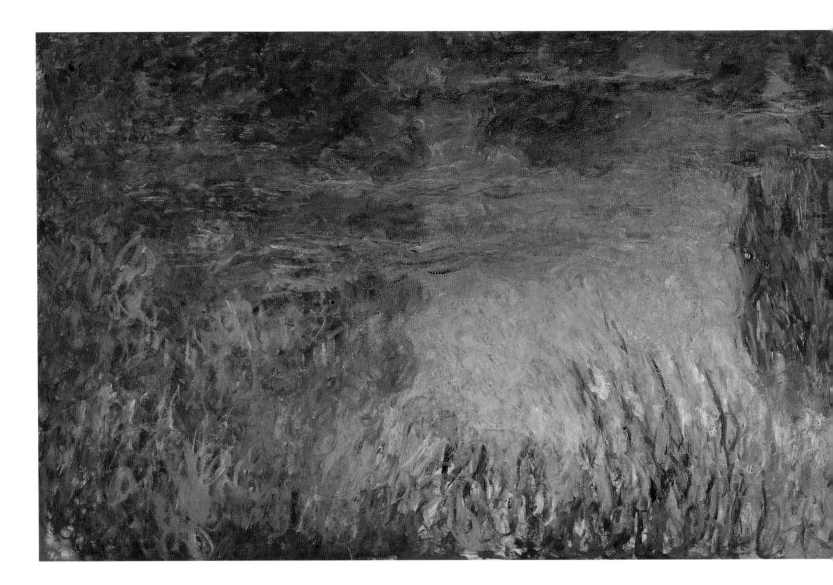

'This endless measure of his dream and of the dream of life, he formulated, resumed, and formulated again and unceasingly through the wild dream of his art before the luminous abyss of the water-lily pond. There he found, so to speak, the last word of things, if things have a first and last word. He discovered and demonstrated that everything is everywhere, and that after running around the world worshipping the light that brightens it, he knew that this light came to be reflected with all its

1913-26 ❖ THROUGH THE LOOKING GLASS

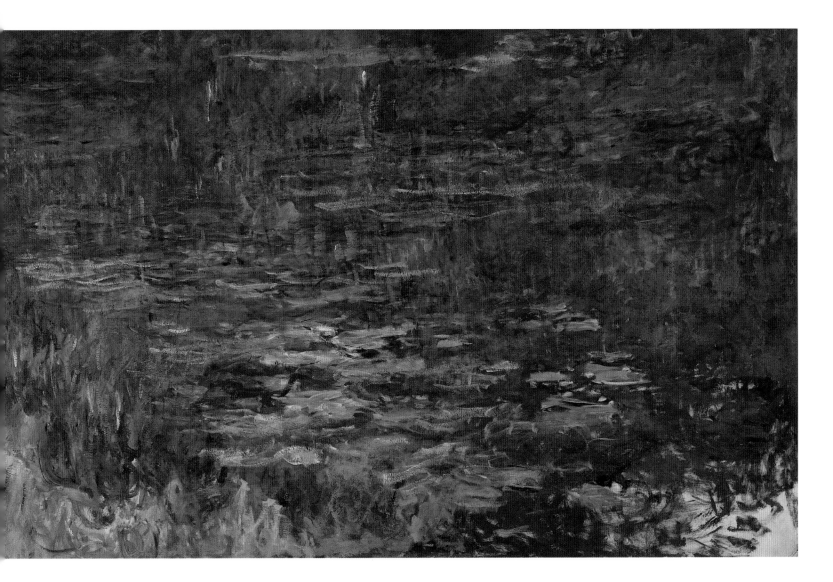

splendours and mysteries in the magical hollow surrounded by the foliage of willows and bamboo, by

flowering irises and rose bushes, through the mirror of water from which burst strange flowers which

seem even more silent and hermetic than all the others.' Gustave Geffroy

Sunset (*above*), *two panels in the first room. Autumn colours reflected in the water (*overleaf*) create a similar effect on the pond today.*

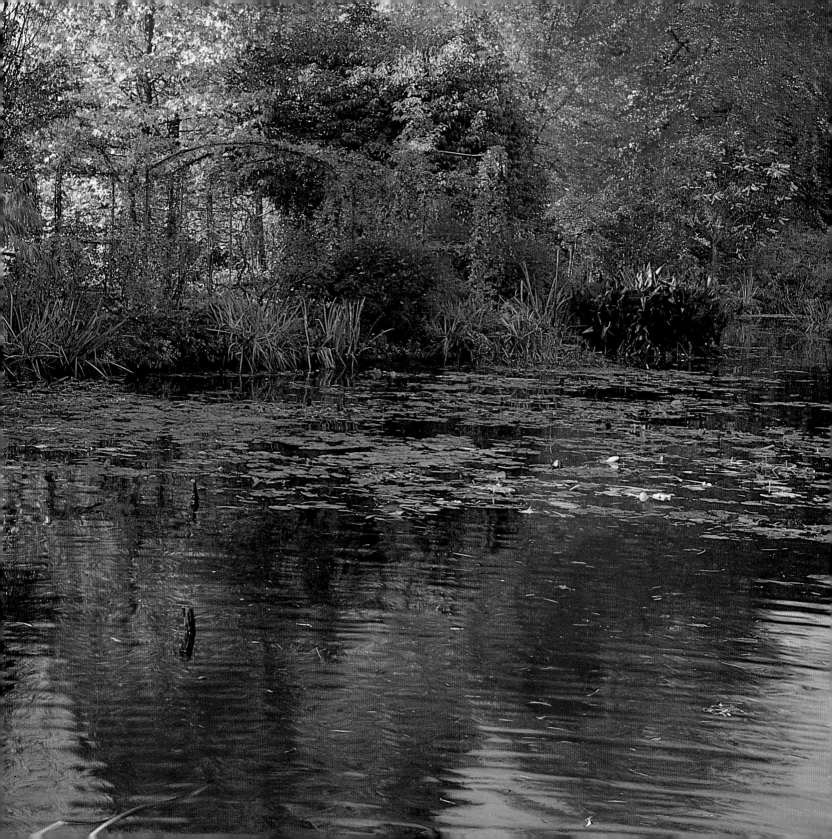

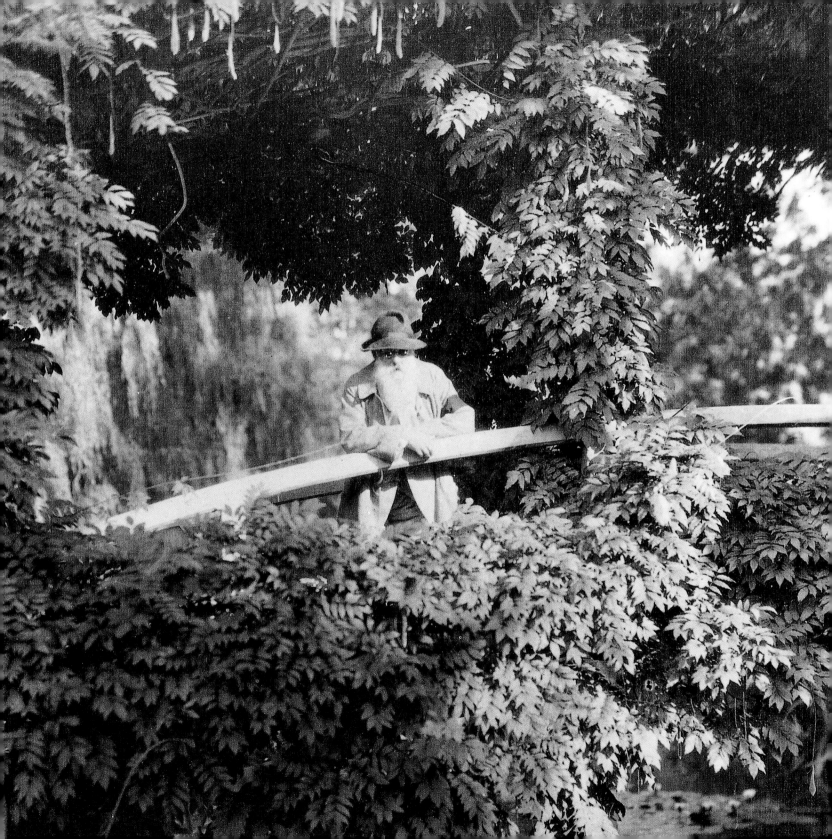

In the aftermath of the war, Monet's eyes deteriorated badly and it is in the furious, chaotic compositions that followed, with their violent reds and muddy trench-like colours, that we find Monet's real war paintings. By 1923 he was living in such a fog that he had to have the cataract operation and, as he had anticipated, his vision changed completely. 'The deformations and exaggerated colours drive me absolutely mad,' he wrote to his oculist, Dr Coutela; 'if I have always to see nature as I see it now, I would prefer to be blind and to keep the memory of the beauties which I've always seen'. But tinted glasses eventually restored his sense of colour and, finding himself in 'a second youth', he energetically began throwing unwanted paintings and panels on to the garden bonfires, well aware that after his death no one else would dare.

'I have a real fear that you might burn those beautiful, grandiose, mysterious, savage things which you showed me', wrote the art critic Louis Gillet to him – a dread shared by his whole entourage, equally worried by the way he was ruining his panels by endlessly retouching them. Coaxed, cajoled and chided by Clemenceau, Monet finally agreed to leave them. 'The panels are finished and won't be touched again. But it's beyond his strength to separate himself from them', wrote Clemenceau. Part and parcel of him, they did not leave the studio; and in his weakening and in his dying, Monet's soul remained strong, nourished by the 'music' of his art. For each mural is a movement of a symphonic

Monet, leaning on the Japanese bridge in his eighty-sixth year, cuts a diminutive figure surrounded by the vigour and vitality of his 'creation'. After 5 December 1926 Monet vanished from the bridge for ever.

poem which he composed and conducted, tracing the music with his hands across the canvases. Every brushstroke added another note to his lyrical scores; the chords became harmonies, harmonies of colour, hymns to light. This is the pulse that resonates off the walls of the Orangerie.

The *Grandes Décorations*, intended initially as a great decorative cycle, 'lost their character as a background to the good life', Virginia Spate concludes, 'and became, despite their sensuousness, so austere, so intense and so demanding that the idea of dining in their presence is unthinkable'.

They are the crowning glory of Monet as an artist and as a man struggling against the odds. The real legacy Monet left after his death on 5 December 1926 was the example of his life. 'I am always trying to do better, *comme le marchand de conserves*' – a playful reference to the advertising slogan of the local grocer – 'but without much result because I am looking for the impossible'. Courage, perseverance and imagination turned a man of vision into a visionary. There was a crisis in the painting of the panels, he told Clemenceau, when he knew the 'water looked pasty. It looked thick enough to cut with a knife. The whole play of light had to be redone. I didn't dare. And then I made up my mind to do it. This is to be my last word. You were afraid that I would ruin my painting. So was I. I don't know how, but in the midst of my sorrow a confidence came to me, and despite the film over my eyes, I saw so clearly what needed to be done to stay within the succession of relationships that confidence sustained me . . . I have given my paintings to my country. And I will let my country judge me'.

INDEX

BIBLIOGRAPHY

Aitken, Geneviève, and Delafond, Marianne, *La Collection d'Estampes Japonaises de Claude Monet* (Bibliothèque des Arts, Paris, 1983)

Alphant, Marianne, *Claude Monet: Une Vie dans le Paysage* (Hazan, Paris, 1993)

Claude Monet au temps de Giverny, exhibition catalogue (Centre Culturel du Marais, Paris, 1983)

Clemenceau, Georges, *Claude Monet: Les Nymphéas* (Librarie Plon, Paris, 1928)

Forge, Andrew, and Gordon, Robert, *Monet* (Abradale Press, Harry N. Abrams Inc., New York, 1989)

Geffroy, Gustave, *Monet, sa vie, son temps, son oeuvre* (2 vols, G. Crès, Paris, 1922; new edition 1980, with an introduction by Claudie Judrin)

Hoschedé, Jean-Pierre, *Claude Monet, ce mal connu* (Pierre Cailler, Geneva, 1960)

Robinson, William, *The English Flower Garden* (15th edition, Amaryllis Press, New York, 1984, original edition John Murray, London, 1933)

Smith, D. Henry II (ed.), *Hiroshige: 100 Famous Views of Edo* (George Braziller Inc, New York, and Thames and Hudson, London, 1986)

Spate, Virginia, *The Colour of Time: Claude Monet* (Rizzoli, New York, 1992)

Stapeley Water Gardens, *Collins Guide to Waterlilies and other aquatic plants*, (Collins, London, 1989)

Stuckey, Charles F., *Monet: Water Lilies* (Hugh Lauter Levin Associates, New York, 1988)

Stuckey, Charles F., ed., *Monet: a Retrospective* (Bay Books, New York, 1985)

Wildenstein, Daniel, *Monet, catalogue raisonné* (1st edition, La Bibliothèque des Arts, Lausanne-Paris, Vol. I, 1974, Vols II and III, 1979; Vol. IV, 1985, Vol. V, 1992; and 2nd edition, Vols, 1, II, III and IV, Benedikt Taschen Verlag GmbH, Germany, 1996)

ARTICLES

Latour-Marliac, Joseph Bory, translated and adapted by J.M. Berghs, 'Hardy Water Lilies and Nelumbos', *The Garden*, 1888

—, article in *L'Encyclopédie Contemporaine Illustrée*, No. 196, 6 November 1892

—, 'Hardy Hybrid Water-Lilies', *Journal of the Royal Horticultural Society*, Vol. XXII, part 3, 9 August 1898

Robinson, William, 'Garden Flora: the New Hardy Water Lilies', *The Garden*, 23 December 1893

AUTHOR'S ACKNOWLEDGMENTS

First and foremost to my two Annes - Anne Askwith the editor and Anne Wilson the designer, with whom I have worked hand in glove and who continue to pull rabbits out of hats. My thanks also to Erica Hunningher and Caroline Bugler; to Sue Gladstone for her wonderful job in securing the paintings we wanted; and to Barbara and Ray Davies of Stapeley Water Gardens who by buying Latour-Marliac's nursery in France have saved it, especially to Barbara for her generous help and time in providing all the articles by Latour-Marliac, often accompanied by long explanations filling in the background. All the water lily close-ups were taken at the Latour-Marliac nursery, and my thanks to Ray Davies for identifying them. I am also most grateful to Mme Lindsey for allowing me to photograph Monet's garden in Giverny.

This book was photographed on Fuji Velvia film with a Leica R5 camera and lenses.

PUBLISHERS' ACKNOWLEDGMENTS

The Publishers would like to thank Etablissements Botaniques Latour-Marliac, 47110 Le Temple-sur-Lot, Lot-et-Garonne, France for giving Vivian Russell permission to take the photographs on the following pages: 8/9, 30/31, 34, 35, 39, 40/41, 60/61, 64, 70. The Publishers would also like to thank Ruth Carim for her assistance, and Helen Baz for the index.

Editor Anne Askwith *Editorial Assistant* Tom Windross
Picture Researcher Sue Gladstone *Production* Vivien Antwi
Editorial Director Erica Hunningher *Art Director* Caroline Hillier

PHOTOGRAPHIC ACKNOWLEDGMENTS

The Publishers have made every effort to contact holders of copyright works. Any copyright-holders we have been unable to reach are invited to contact the Publishers so that a full acknowledgment may be given in subsequent editions. For permission to reproduce the paintings and archive photographs on the following pages and for supplying photographs, the Publishers thank those listed below.

Endpapers © photos RMN; 5 and 72-73 Portland Art Museum, Portland, Oregon (Helen Thurston Ayer Fund); 6-7 © Collection Philippe Piguet; 10-11 © photo RMN; 13 Private collection; 16-17 Sotheby's Picture Library; 18-19 Shelburne Museum, Shelburne, Vermont (photo Ken Burris); 20-21 Sterling and Francine Clark Art Institute, Williamstown, Massachusetts; 22 Private collection; 22-23 Christie's Images; 25, 26 Document Archives Durand-Ruel; 31 Stapeley Water Gardens; 33 Collection of Barbara and Ray Davies, Stapeley Water Gardens; 36 Private collection; 38 Stapeley Water Gardens; 43 Lilla Cabot Perry Papers, Archives of American Art, Smithsonian Institution (photo Margaret Perry); 44 Private collection; 46 Sotheby's Picture Library; 48 (left) Private collection; 48-49 Los Angeles County Museum of Art (Bequest of Mrs Fred Hathaway Bixby); 50-51 © 1998 Board of Trustees, National Gallery of Art, Washington (Gift of Victoria Nebeker Coberly, in memory of her son John W. Mudd, and Walter H. and Leonore Annenberg); 54 Bridgeman Art Library (photo Peter Willi); 58 (above) Private collection; 58 (below) © Collection Philippe Piguet; 60 © Collection Philippe Piguet; 63 Giraudon/Bridgeman Art Library; 64-65 photograph © 1998 The Art Institute of Chicago (Mr and Mrs Martin A. Ryerson Collection, 1933.1157) All Rights Reserved; 66 Document Archives Durand-Ruel; 67 © Collection Philippe Piguet; 68 (inset) Roger-Viollet, Paris/Bridgeman Art Library; 68-69 © photo RMN; 72 © Collection Philippe Piguet; 77 Document Archives Durand-Ruel; 78-79, 80-81, 82-83, 84-85 © photos RMN; 88 Musée Clemenceau, Paris

Molly Russell

VIVIAN RUSSELL is a writer, photographer, film-maker and gardener. *Monet's Garden: Through the Seasons at Giverny* won her the Garden Writer's Guild Award for the best general gardening book of 1995 and established her reputation for combining superb photography with a gift for writing. She is also the author and photographer of the highly praised *Edith Wharton's Italian Gardens*, and photographer for Peter Beale's *Visions of Roses*.

Jacket design by Anne Wilson

Also available from Bulfinch Press:

EDITH WHARTON'S ITALIAN GARDENS
By Vivian Russell

0-8212-2397-6

VISIONS OF ROSES
Text by Peter Beale and photographs by Vivian Russell

0-8212-2318-6

A Bulfinch Press Book
Little, Brown and Company
Boston • New York • Toronto • London

PRINTED IN HONG KONG